IMAGES
of America

VANISHING
ORANGE COUNTY

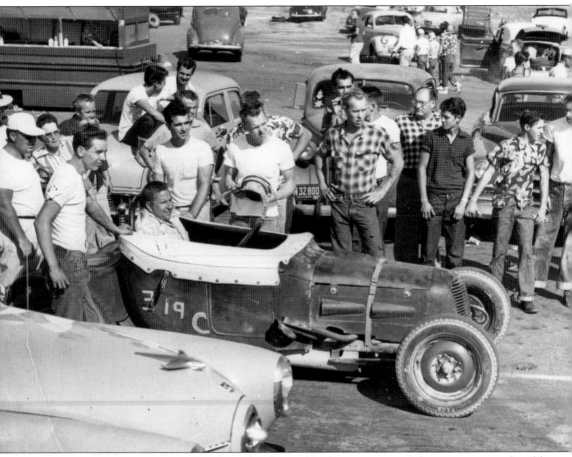

Back in the 1950s, what is thought to be the world's first commercial drag strip ran at the old Orange County Airport. It was closed in 1959 due to the ever-increasing amount of planes in the area. (Courtesy of the Orange County Archives.)

ON THE COVER: Pictured on the cover is the old Buffalo Ranch, a Newport tourist attraction that opened in 1955. Families could drive around the ranch and watch buffalo graze, then visit a Native American village, and even eat buffalo burgers. By the 1970s, the place had closed, and most of the remaining buffalo had been shipped off to Catalina, where some offspring probably still roam. (Courtesy of the Orange County Archives.)

IMAGES
of America

VANISHING
ORANGE COUNTY

Chris Epting

ARCADIA
PUBLISHING

Published by Arcadia Publishing
Charleston SC, Chicago IL, Portsmouth NH, San Francisco CA

Printed in the United States of America

Library of Congress Catalog Card Number: 2008930697

For all general information contact Arcadia Publishing at:
Telephone 843-853-2070
Fax 843-853-0044
E-mail sales@arcadiapublishing.com
For customer service and orders:
Toll-Free 1-888-313-2665

Visit us on the Internet at www.arcadiapublishing.com

With love, to my family: wife, Jean; son, Charles; daughter, Claire; and my mom, Louise.

CONTENTS

ACKNOWLEDGMENTS

Working on this book has been yet another terrific experience. Special thanks go to the exceptional historian Chris Jepsen, assistant archivist at the Orange County archives. He, along with county archivist Phil Brigandi, was extremely generous both with photographs and knowledge. (And check out Chris's great Web site, ochistorical.blogspot.com.) Thanks as well to Bob Blankman, historian at the First American Corporation. To the staff at the *Huntington Beach Independent* newspaper: thanks for the support. Unless otherwise noted, all images in this book are courtesy of and can be located through these generous institutions: the Orange County archives and the First American Corporation. To Jerry Roberts, Devon E. E. Weston, Kai Oliver-Kurtin, Kate Crawford, and the rest of the Arcadia Publishing staff: thank you for your tireless efforts in helping to document our nation's history.

I'd also like to thank my wife, Jean, for her typical patience and support. To my daughter, Claire, and son, Charlie—well, what can you say to the world's best kids?

And to each one of you holding this book right now: thank you so much for your interest.

INTRODUCTION

When I began this book, I had lived in Orange County with my family for about 10 years. Some time last year, I discovered the Web site OCThen.com, Memories of Orange County. Reading the many remembrances of people who grew up in Orange County was a touching, fascinating experience. In particular was a great piece by local writer Suzanne Broughton called "You Know You Grew Up in Orange County in the 70s," which tied together random, whimsical memories into one entertaining composition.

What struck me most about these memories and recollections was how much the county had changed since many of these folks grew up back in the 1950s, 1960s, and 1970s. In particular, many of the essays recalled wide open spaces and strawberry fields, orange groves, rolling hills, drive-in movies and malt shops, endless beaches to go along with the endless summers—the ultimate Southern California experiences mixed with an almost Midwestern sense of innocence and nostalgic warmth and comfort. But while these memories were as sharp as ever, many of the places (and spaces) that inspired the thoughts were gone, replaced by the sprawl of an increasingly developed suburban society. But that's progress . . . right?

Orange County was formally created in 1889 as a political entity separate from the county of Los Angeles. The onetime wilderness had evolved into irrigated farmlands and easy-to-live-in communities supported by a healthy, year-round harvest of lemons, avocados, walnuts, Valencia oranges, and more. Agriculture was the primary industry in the new county, and due to the many blossoming orange groves, the region was christened "Orange County." Soon after, big things started happening.

The sleepy town of Huntington Beach was transformed after the discovery of oil in the 1920s. In 1926, the Pacific Coast Highway opened, connecting Huntington Beach and Newport Beach. The year 1927 saw Laguna Beach become incorporated with a population of 1,900. Then, in 1928, San Clemente was incorporated with a population of 650, and Doheny Beach State Park opened in 1931 on Capistrano Beach property. In 1943, the El Toro Marine Base opened on 4,000 acres of Irvine Ranch. In 1952, the Los Alamitos racetrack opened. In 1953, Buena Park was incorporated with Costa Mesa following the next year. The Santa Ana Freeway (I-5) opened in 1954, and in 1955, Walt Disney opened his Magic Kingdom in Anaheim.

In the late 1950s, aerospace firms and light industry began expanding here, and the increasing population meant more and more jobs at hospitals, restaurants, and stores.

South Orange County began to grow incredibly in the 1960s with master-planned communities such as Irvine, Mission Viejo, and Laguna Niguel. Aliso Viejo, Rancho Santa Margarita, Ladera Ranch, and others followed in the 1980s and 1990s. Today Orange County is home to more than three million residents in 34 incorporated cities.

And as Orange County continues to grow, many of the things that have endeared it to so many locals continue to vanish. The orange groves and strawberry fields that used to perfume the air with their sweet, fragrant aromas are gone, replaced by industrial parks, freeways, and congestion. The drive-in theaters are gone. Many of the old stores and restaurants have vanished. But that

is not to say the county is not still a beautiful place to live and grow up; it is. However, parts of it seem on the verge of erasing much of the past.

The final chapter of this book ("Still Standing!") recognizes some of the places I like that have managed to survive, in some form or another. There are many more, of course, but these are some personal favorites. But who knows how long they will be in existence.

For today, let us be thankful for places like Old Towne Orange and Main Street in Seal Beach that elegantly preserve the past while still living in the present; rich pockets of exotic culture like Little Saigon in Westminster; and for all of the historic nooks and crannies that still exist in Fullerton, La Habra, Tustin, Placentia, Brea, Santa Ana, San Juan Capistrano, Anaheim, Huntington Beach, and other places. Each city has its own personality and history. In fact, you could probably do a "vanishing" title for each one of them (and eventually maybe someone will)! Every city in Orange County has a little something special that connects us to the rich history of the area, and if we all go out and explore them, these places will have better chances of surviving the sometimes cruel effects of sprawl.

Suffice it to say, properly balancing the entire county in one book would be a tough task. To that end, I have tried to include as many diverse places as possible. However, sometimes the availability of historic photographs dictates what can or cannot be presented. For things that have been omitted, or for any errors that may be included, I am sorry. There is so much to cover and simply not enough space.

All that being said, I hope you enjoy this wistful, yet sometimes bittersweet collection of photographs in *Vanishing Orange County*. From the glorious groves, to the infamous flood, to the dance halls, the farms, amusement parks, orchards, airports, trains, and so on, this place has played (and continues to play) a huge role in the history of Southern California. Many thanks to the numerous hardworking historical societies in Orange County; your efforts are eternally appreciated.

To all of you who had the good fortune to grow up here in those simpler days, before so much of it vanished, I hope some of these images bring back at least a glimmer of your home's storied past. For the visitors and transplants like myself, let us celebrate what once was Orange County—"Nature's Prolific Wonderland," as an old motto once boomed.

One

AGRICULTURE

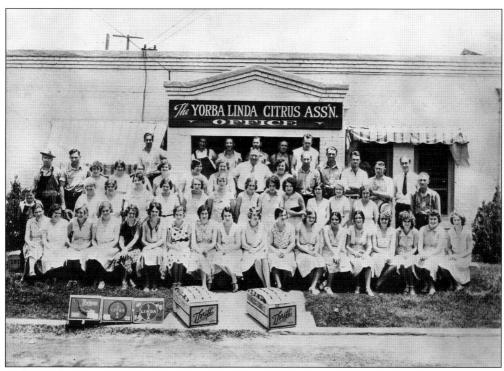

Yorba Linda was an ideal place to grow many crops, such as alfalfa, asparagus, figs, potatoes, and walnuts. Orange and lemon groves, however, were the most popular agricultural products. As a result, the Yorba Linda Citrus Association was created in 1912. On June 29, 1929, the Yorba Linda Citrus Association's packinghouse was destroyed by fire.

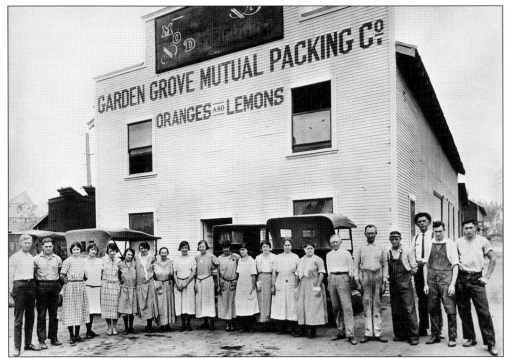

The Garden Grove Mutual Packing Company, pictured around 1915, was founded by Alonzo Cook in 1874, and a school district and Methodist church were organized that year. The city existed as a small rural crossroads until the railroad arrived in 1905. With the large exportation of crops of oranges, walnuts, chili peppers, and later, strawberries, the town grew quickly. Tragically, the 1933 Long Beach earthquake destroyed much of the central business district, but the post–World War II boom led, once again, to rapid development, and Garden Grove was incorporated as a city in 1956 with about 44,000 residents.

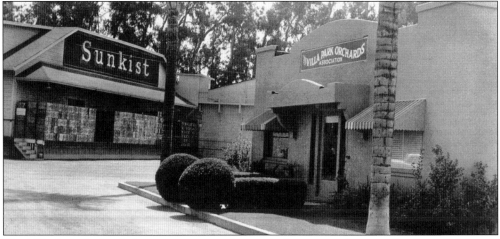

The Villa Park Orchards Association came of age with the citrus industry in Southern California. It was organized in 1912 by a small group of growers in east Orange County to harvest, pack, and market their citrus fruit. The association today has 350 members with acreage extending from Southern to Central California. Harvesting approximately four million field boxes of citrus annually, they operate packinghouses in Orange and Fillmore, California.

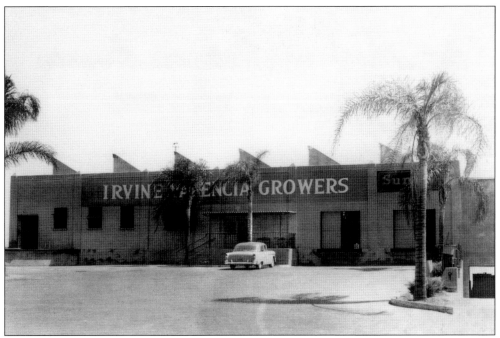

This c. 1930s image shows the Irvine Valencia Growers packinghouse, built in 1927 just southwest of the intersection of Jeffrey Road and Irvine Boulevard in Irvine. Irvine Valencia Growers, founded in 1926, is still in business, and the packinghouse still stands.

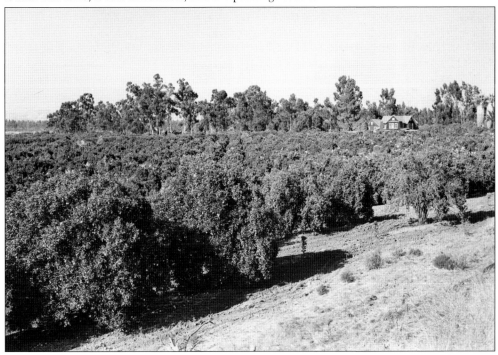

By 1910, the Irvine Ranch was thought to be California's most productive farm and the state's largest producer of beans and barley. As of 1930, when this image was taken, the ranch's crops ranged from beans, cauliflower, and barley to oranges, grapes, and papayas.

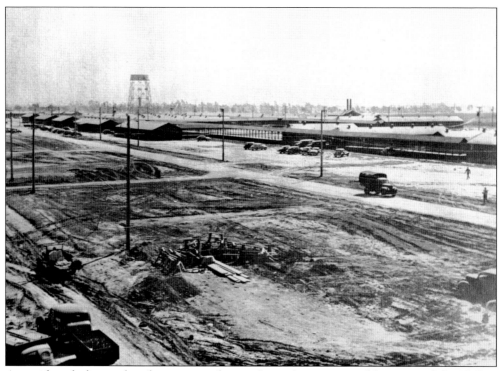

An unidentified agricultural processing plant in Santa Ana is pictured here around the 1940s.

Orange Orchard in California.

Orange County got its name from the fruit, and that is why many postcards like these were produced back in the 1920s and 1930s—to help promote the many fragrant, bountiful orchards that were common in so many of the county's cities and towns.

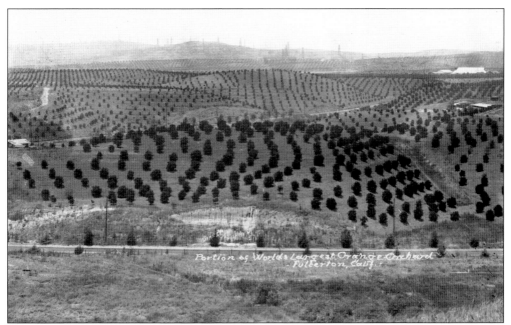

This is the Bastanchury Ranch in Fullerton around the 1920s, then called the "World's Largest Orange Orchard." Domingo Bastanchury and his wife, Maria, were Basque immigrants who came to this area in 1870 and purchased land in the Fullerton hills for sheepherding. The Bastanchury family acquired more wealth during the oil boom of the 1920s, and at the peak of this family's success, its holdings were so extensive that all three railroads—the Union Pacific, the Santa Fe, and the Pacific Electric—ran spur lines to the ranch house. Despite this success, their ranch went bankrupt during the 1930s. The area has since been developed.

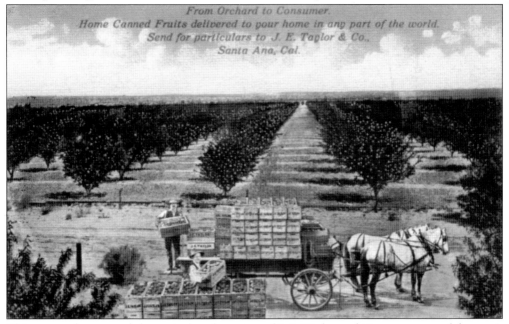

This postcard promoted the agricultural services of J. E. Taylor and Company, one of the area's largest orange growers, around the turn of the 20th century.

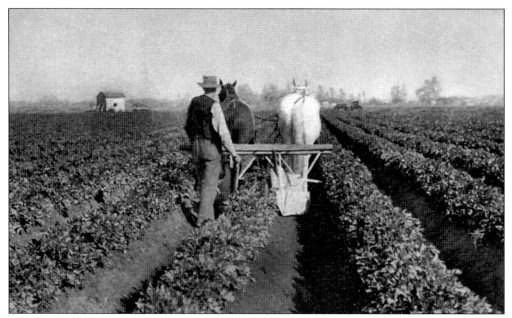

Celery was long one of the most prosperous crops grown in Orange County, as this turn of the century postcard indicates. Celery was hard to grow and expensive to buy. Interestingly, back then celery stalks were often placed in elaborate vases, becoming the featured centerpiece of tables in well-to-do homes. In 1900, Orange County celery growers produced an eye-opening two crops a year, which allowed them to export 1,800 train carloads of the "green gold" annually.

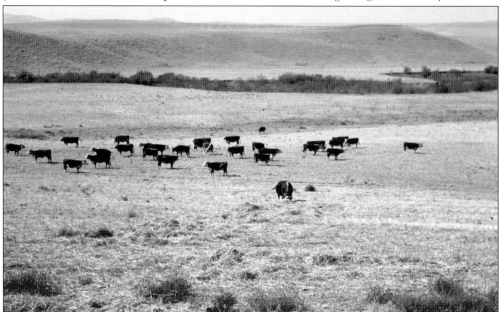

In 1874, Lewis Moulton purchased a 22,000-acre area called Rancho Niguel from Don Juan Avila. Moulton and his partner, Jean Piedra Daguerre, used the ranch to raise sheep and cattle. The Moulton Ranch was eventually subdivided in the early 1960s, part of which is now recognized as Laguna Hills, incorporated as a city in 1991. This image of the Moulton Ranch is from the early 1900s.

The excellent Orange County historian Chris Jepsen provided the following information about this gentleman in the lettuce field: "Harry Leslie Dady was a rancher in Santa Ana. He was born November 26, 1895, in Nebraska. He was still in Nebraska in 1917 when he registered for the draft [World War I]. At the time, he was self-employed as a farmer/stock raiser. He died January 13, 1990, in Orange County at age 94."

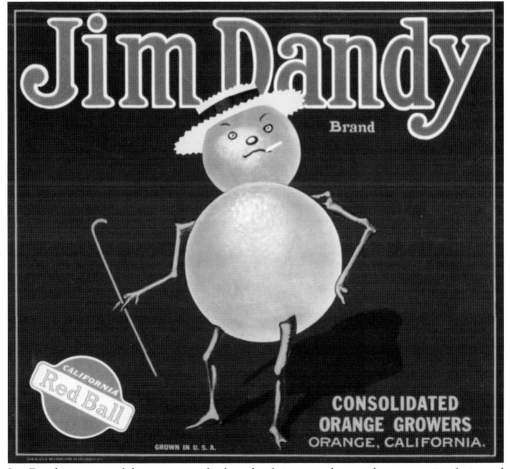

Jim Dandy was one of the many popular brands of citrus produce packagers growing fruits and vegetables in Orange County. Many of the original labels are now collectible works of art.

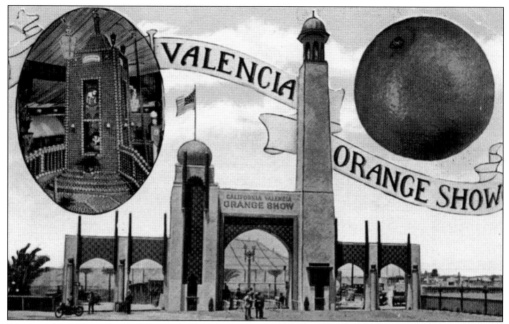

During the 1920s, the California Valencia Orange Show was held in a large tent in Anaheim at a site that later became La Palma Park. All displays were constructed of local Valencia oranges. Growers went all out, and each year the displays became more elaborate, representing exotic themes like ancient Egypt, Aladdin's lamp, and Robinson Crusoe. In 1927, more than $15,000 worth of oranges were sacrificed to art, or at least to public relations. The show folded its tent after a decade, but it eventually became the now-famous Orange County Fair.

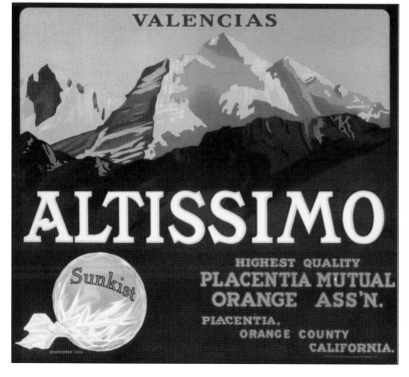

Altissimo was another one of the many local produce companies that packaged fruits and vegetables in Orange County many years ago.

This is what the famed Moulton Ranch looked like just before it was subdivided in the early 1960s to become Laguna Hills. Today a freeway cuts through the approximate site where these animals are grazing

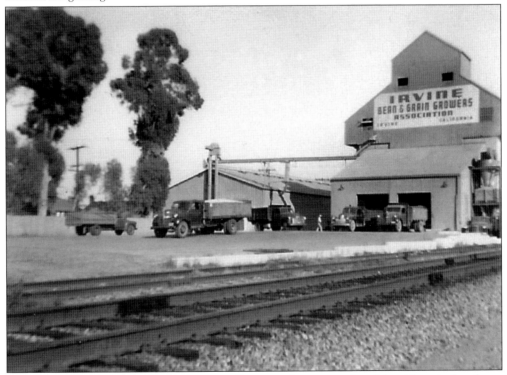

Old Town Irvine on Sand Canyon Avenue still exists today, a reminder of the rich agricultural past of what has become one of California's most urban counties. Founded in 1887 as the distribution and storage center of the 125,000-acre Irvine Ranch, Old Town Irvine was to develop over the years a bean and grain storage warehouse (1895) and granary (1947) known as the Irvine Bean and Grain Grower's Building (seen in this photograph); a blacksmith's shop (1916); a hotel (1913); a general store (1911); and an employees' bungalow (1915). All of these structures have been rehabilitated for commercial uses, and their exteriors have been faithfully maintained

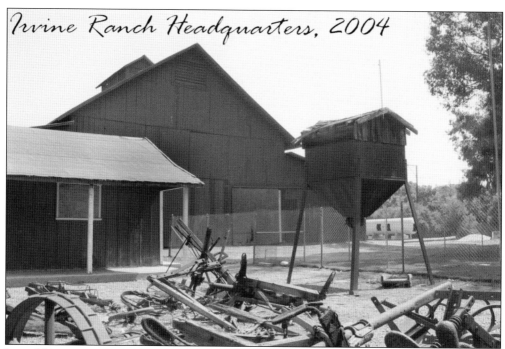

Irvine Ranch Headquarters, 2004

Incredibly, at one time, the Irvine Ranch stretched more than 100,000 acres, reaching from the coast to the mountains and to the Riverside County line. When James Irvine Jr. took over the ranch in 1892, he oversaw the transition from livestock grazing to agriculture. Today, at the corner of Jamboree Road and Irvine Boulevard, less than a mile from what is now the Irvine Marketplace, is the site of the home and headquarters from which James Irvine II and his family ran their empire. The photograph is from 2004.

In 1962, a large part of the Irvine Ranch was still intact and producing fruits and vegetables. Today virtually every acre has been developed. However, at the Irvine Ranch Historical Park, one can find the site of the original Irvine Ranch Headquarters, once at 13042 Old Myford Road in Irvine. The Irvine Ranch Historic Park contains an interesting collection of buildings that represent the history of the Irvine Ranch. The park site includes the ranch's headquarters building; the James Irvine II home, which houses the Katie Wheeler Branch Library of the Orange County Public Library; and numerous barns and residences.

Two

ROADS

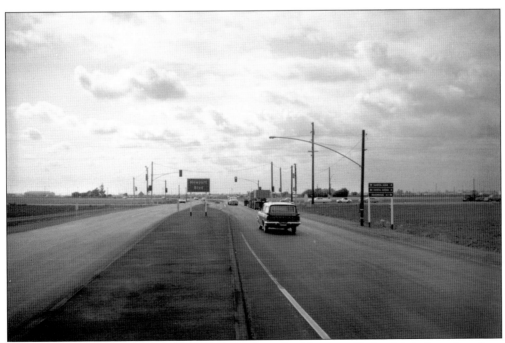

This photograph from 1963 shows Newport Boulevard in Newport. Today this is the point where the 55 Freeway passes over Main Street, near where Main Street makes a 90-degree turn.

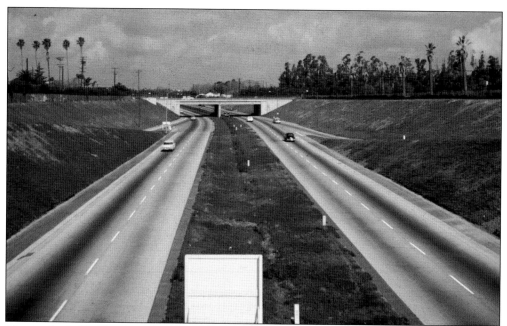

This is the 5 (Golden State) Freeway at the First Street exit in Santa Ana, around the 1960s. Originally built as U.S. Route 99, the roadway was re-signed as Interstate 5 in 1964. Many of the 5's current traffic woes have yet to emerge in this photograph. And notice the pleasant lack of billboard advertising.

The sign on the hill reads, "Laguna Niguel welcomes you to the choice community." The view in this 1976 shot is Crown Valley Parkway and Forbes Road. The name "Laguna Niguel" is derived from the Spanish word "Laguna," which means lagoon, and the word "Nigueli," which was the name of a Juaneño Native American village once located on nearby Aliso Creek. The city was primarily built after 1980 as an unincorporated master-planned community located in the San Joaquin Hills near Laguna Beach. It borders Laguna Beach, Dana Point, San Juan Capistrano, Mission Viejo, Laguna Hills, and Aliso Viejo.

This is El Toro Road in Aliso Viejo around 1965. The view here is looking east toward the Santa Ana Mountains. In this predevelopment era, the road is a winding country lane that snakes into the foothills and up toward Silverado Canyon. Today the road is a tangled congestion of mini- and strip malls.

Were Southern California freeways ever really this easygoing? Apparently so. In this late 1950s image is the 5 (Golden State) Freeway at El Toto Road. It is a much different scene today.

This is the view of Mission Viejo in 1976 where the Avery and Maguerite Parkways meet. Mission Viejo is considered one of the largest master-planned communities ever built under a single project in the United States and is rivaled only by Highlands Ranch, Colorado, in its size. As of the 2006 census, the city had a total population of 97,997. The city's name is a reference to Rancho Mission Viejo, a large Spanish land grant from which the community was founded. There is no Spanish mission in Mission Viejo, and the name is an improper use of a masculine adjective with a feminine noun. The correct Spanish term, meaning "old mission," is *misión vieja*.

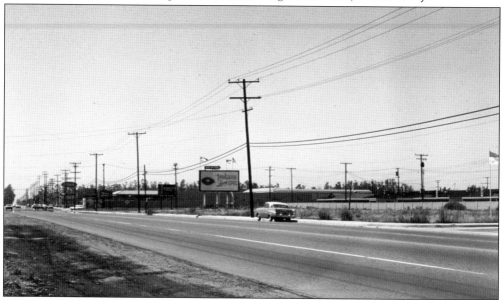

This is Tustin's Seventeenth Street in April 1966. Like many other images in this book, this scene is virtually unrecognizable today as the same street due to the amount of development that has since occurred. Columbus Tustin, a carriage maker from Northern California, founded the city in the 1870s. Tustin was incorporated in 1927 with a population of about 900. During World War II, a navy antisubmarine airship base (later to become a marine corps helicopter station) was established in unincorporated land south of the city.

This is the 5 (Golden State) Freeway heading south through the Irvine area around the 1960s. This image provides one of the most startling contrasts in this book in terms of modern comparisons. The freeway today is four times as wide as this picture shows, and it is still backed up bumper to bumper on a regular basis. Back then there were no developments as far as the eye could see, just more rolling hills.

This is Alicia Parkway, running into the Laguna Hills area back in 1968. Laguna Hills is built on one of the major land grants developed during the rancho era. Following Mexico's independence from Spain in 1821, those who had served in the government, or who had friends in power, were given vast acreage for cattle grazing. Rancho Lomas de Santiago, Rancho San Joaquin, and Rancho Niguel covered much of the western portion of the Saddleback Valley. Don Juan Avila was granted the 13,000-acre Rancho Niguel on which Laguna Hills is now located.

This wonderfully simple view is West Katella Avenue and North Main Street in the city of Orange in November 1964. Today, at this exact site, there are more cars than are seen here, due primarily to the two large shopping complexes that face each other.

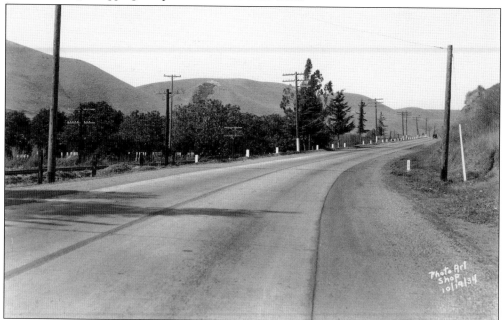

This is how the U.S. 101 Freeway looked near San Juan Capistrano on October 19, 1934. When 101 went through south Orange County, the area was still open country, a far cry from today's mega-developed landscape. Route 101 remained as a two- and three-lane road until 1959, when it was finally replaced by a four-lane freeway. (This is right near the famed Mission San Juan Capistrano, which was founded on All Saints Day, November 1, 1776, by Spanish Catholics of the Franciscan order.)

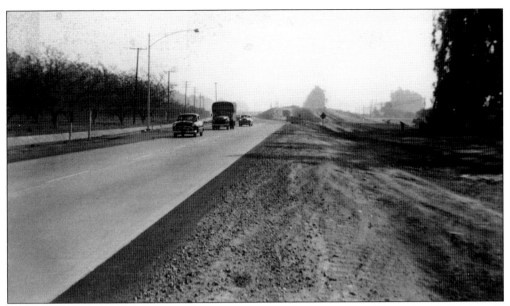

The information for this photograph comes courtesy of renowned local historian Phil Brigandi, discussing "Culver's Corner . . . the three-way intersection of Culver Drive, Trabuco Road, and old Highway 101 [now the route of Interstate 5]. The junction was a renowned, though sometimes dangerous landmark on the Irvine Ranch for many years. It was known as The Windmill in the late 19th century, when James Sleeper [the historian's grandfather] farmed there. Then Fred "Humpy" Culver—not to be confused with his brother, "Gimpy"—took over the lease and built a substantial home at the corner. He died in 1918, but the name survived for many years." The photograph depicts Highway 101 near Culver's Corner in Irvine in 1957.

This charming postcard shows San Juan Capistrano in the 1950s, when Highway 101 was still the primary north-south route.

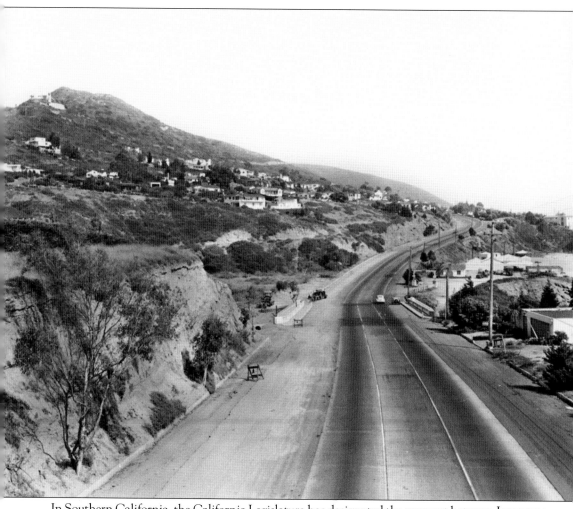

In Southern California, the California Legislature has designated the segment between Interstate 5 in Dana Point and U.S. Route 101 near Oxnard as Pacific Coast Highway (commonly referred to as PCH). This quaint image shows the road south in the 1930s, just before hitting Laguna.

Three

MAPS AND SIGNS

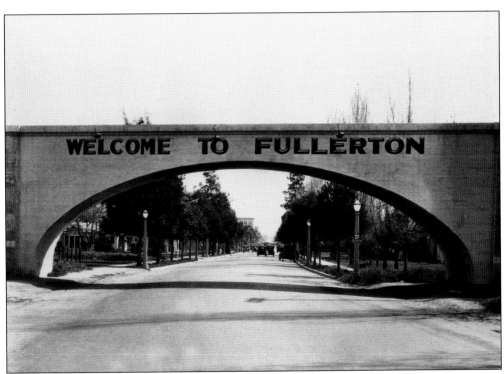

The city of Fullerton was founded in 1887 by George and Edward Amerige and named for George H. Fullerton, who secured the land on behalf of the Atchison, Topeka, and Santa Fe Railway. Early in its history, Fullerton was a center for petroleum extraction, transportation, manufacturing, and agriculture, primarily groves of Valencia oranges and other citrus crops. Today it is home to several educational institutions, including California State University, Fullerton. This image of people being welcomed into the city was taken along Harbor Boulevard in the 1920s.

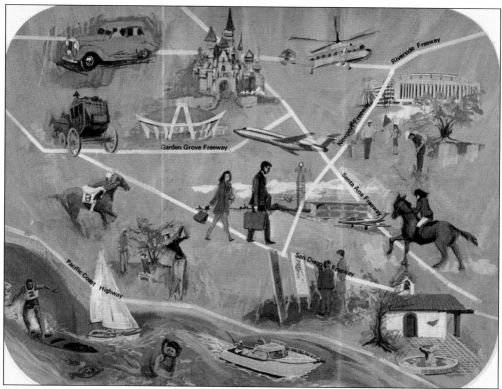

This promotional map from 1968 highlights the more popular aspects of the county, elements that made it distinctly different from neighboring Los Angeles County: Anaheim Stadium, Disneyland, horseback riding, golf, surfing, and boating. These popular activities are still part of what gives Orange County its unique flavor today.

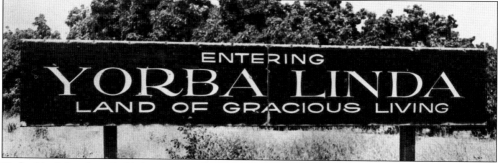

Yorba Linda has long held the motto, "Land of Gracious Living." (This sign on the edge of town dates back to the 1920s.) The name Yorba dates as far back as 1769 when Jose Yorba was part of a Spanish expedition exploring the area known today as Orange County. In 1809, Yorba petitioned the king of Spain for a land grant and was awarded 62,000 acres of land that came to be known as Rancho Santiago de Santa Ana. Nearly 100 years later, a Fullerton resident and partial owner of the former Yorba lands, Jacob Stern, sold a large portion to the Janss Corporation. The Janss Corporation subdivided this property and named the new town "Yorba Linda." As for the origin of the name, "Yorba" is from the early land grant family and "Linda" means "pretty" in Spanish. One of the city's most famous residents was the late former president Richard Nixon, who was born and raised in Yorba Linda. Today Yorba Linda serves as the home of Nixon's presidential library, a very popular attraction.

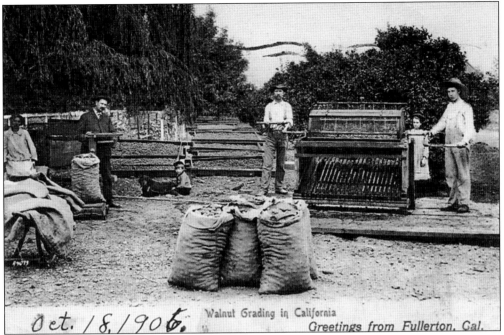

Oct. / 8, / 90 6. Walnut Grading in California

Greetings from Fullerton, Cal.

The year is 1906, and this Santa Ana postcard proudly displays some bags of freshly picked walnuts from one of Orange County's many farms.

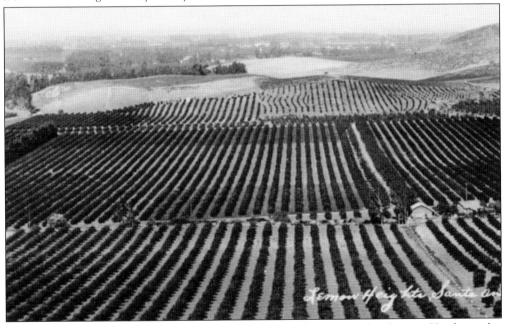

Lemon Heights Santa An

This Lemon Heights postcard places the citrus farm in Santa Ana, but Lemon Heights today is actually an upscale part of Orange. The area was desert-like until the 1920s, when two men, C. E. Utt and James Irvine, developed Lemon Heights. At that time, the hilly area was part of the Irvine Ranch. Utt owned the Utt Juice Company at the corner of Main Street and Prospect Avenue, and his company planted lemon and eucalyptus trees and pumped water into the area, so the land could be subdivided. Today, of course, the image on the card is a memory long gone.

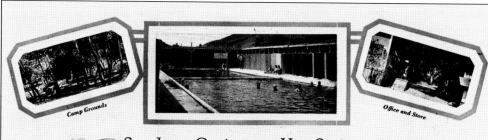

Camp Grounds

Office and Store

San Juan Capistrano Hot Springs

SAN JUAN CAPISTRANO HOT SPRINGS are nestled in a grove of luxuriant live oak and sycamore trees and the natural charm of the resort has been preserved.

The 52 mineral springs rise in the San Juan Capistrano canyon only 12 miles from the historic and picturesque mission whose name they bear.

The bracing mountain air, and the life-giving heat of a southern sun, tempered by a refreshing breeze from the Pacific Ocean make the climate ideal for health and pleasure seekers.

As a place of relaxation and quiet for convalescing patients or worn-out business people, the San Juan Capistrano Hot Springs are unexcelled. Guests who take the baths each year have found in them a specific for the cure of many ailments. The combination of the baths, the mineral drinking water, and the invigorating out-of-door life works wonders in a short time. These mineral waters are of particular value in treating rheumatism, nervousness, neuralgia, and stomach and kidney disorders.

Swimming

A large open air swimming pool is one of the chief attractions at San Juan Capistrano Hot Springs. Fresh spring water flows into the plunge constantly to insure its cleanliness and the concrete pool beckons invitingly. A swim in this warm mineral water is a joy, summer or winter, and after a dip in the plunge, vitality and pep just bound through the veins.

The sulphur baths of San Juan Capistrano Hot Springs are famous for their curative qualities and are especially effective in cases of liver and blood troubles, neuritis, rheumatism and kindred afflictions.

Those guests interested in the water sports find that the Capistrano springs have a particularly tonic reaction.

A canvas cover is stretched over the tank in summer as a protection from the sun.

Camping Grounds

Many motor parties consider the camping grounds at Capistrano without equal. Well shaded under the live-oaks and sycamores and a near running stream, camping here can be woodsy and yet commodious.

The comfortable cottages and tent-houses are well equipped with modern conveniences, including electric lights; and campers, too, have the full use of the resort attractions.

The dining room is a model of neatness and comfort—large, airy, and screened on all sides.

Amusements

Hiking on good trails to cool, wooded canyons or to peaks over-looking the valley toward the ocean can occupy many happy hours.

Good trout fishing, in season, is found not far from the grounds of the Hot Springs.

A large dancing pavilion with screened windows is the scene of merry, informal parties. The guests find reflected in the social life at San Juan Capistrano Hot Springs the genial atmosphere characteristic of our California hospitality.

The right to refuse accommodations to anyone not desired is reserved, and the rates are subject to change at the discretion of the management.

Tubercular and other objectionable cases are not admitted.

No dogs allowed except on leash.

Phone San Juan Capistrano Hot Springs 8F2

The San Juan Hot Springs resort area, located east of San Juan Capistrano off the Ortega Highway, was closed down in the early 1990s. From the 1950s through the 1970s, this was a popular hot spot throughout Southern California, as this promotional advertisement illustrates. Camping was permitted, and there was even a general store. Some of the ruins remain.

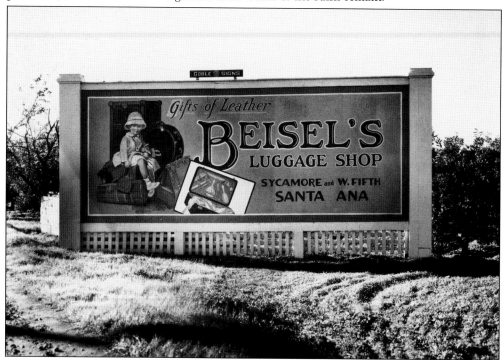

This 1930s billboard touts the old Biesel's Luggage Shop in Santa Ana, featuring "gifts of leather."

Ah, the 1960s in Anaheim. This advertisement shows a boy playing catch with his dad while daughter and mom look on, a picture-perfect representation of the "good life" in Orange County, just the type of promotion designed to lure families who wanted space and safety for their children.

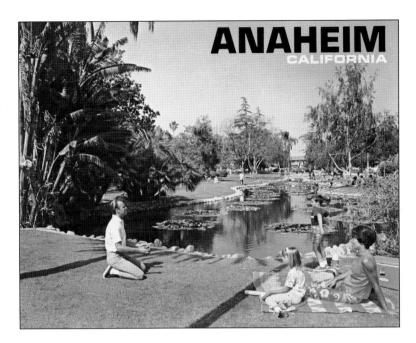

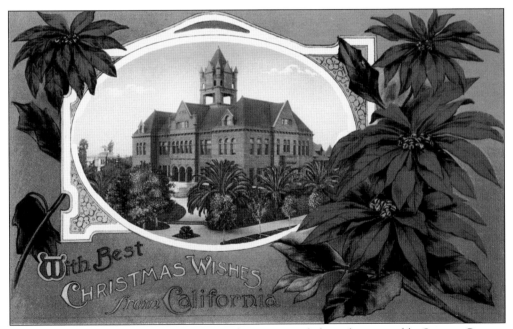

What better building to put on a 1920s Christmas card than the venerable Orange County Courthouse, Southern California's oldest court building, dedicated in 1901? Today the 30,000-square-foot granite and sandstone building has been restored to look much as it had at the turn of the last century. Inside is the Orange County History Center (which includes the Old Courthouse Museum, the Orange County Archives, and the library of the Pacific Coast Archaeological Society), as well as government offices. The building is on the National Register of Historic Places and is a State of California Historic Landmark.

EAST NEWPORT.

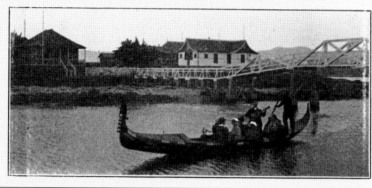

IF YOU WILL JUST SEE IT ONCE YOU WILL BE CONVINCED THAT THERE IS NO BETTER PLACE TO HAVE A BEACH HOME, EITHER FOR SUMMER OR WINTER.

East Newport Town Co.

OWNERS

W. W. WILSON,
MANAGER

ADDRESS
NEWPORT BEACH, CAL.

This 1920s advertisement promotes beach homes in the tony district of East Newport, near Balboa. Note the folks being serenaded in the gondola.

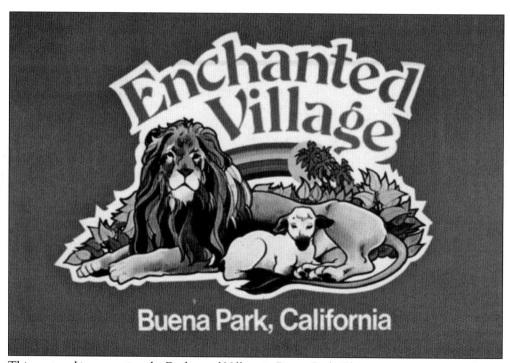

This postcard is promoting the Enchanted Village in Buena Park. This attraction came into being after the Japanese Gardens and Deer Park, located on the same site, closed in the mid-1970s. The Enchanted Village, which featured animal shows and musical revues, closed just several years after that. On the site today, located on Knott Avenue, is an industrial park.

Hobby City used to feature nearly 20 different arts and crafts stores selling everything from Native American crafts to homemade toys, rocks, minerals, stamps, models, and baseball cards. Some of the shops are still open, and the small amusement park, Adventure City, is now part of the 10-acre complex. Hobby City even has a doll museum built as a half-scale replica of the White House. This advertisement is from 1981.

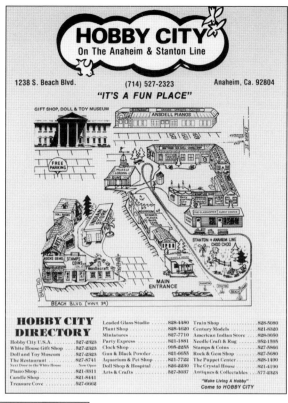

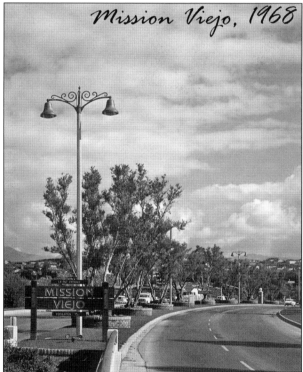

This welcome sign in the city of Mission Viejo dates back to 1968. Early developers in the 1960s dismissed most of the land in the Mission Viejo area as "undevelopable." However, in the early 1970s, urban planner Donald Bren, who would later become the president of the Irvine Company, drafted a master plan that placed roads in the valleys and houses on the hills, contouring to the geography of the area. The plan paid off, and by 1980, much of the city of Mission Viejo was completed. During the late 1970s and the 1980s, houses in Mission Viejo were in such high demand that housing tracts often sold out before construction even began.

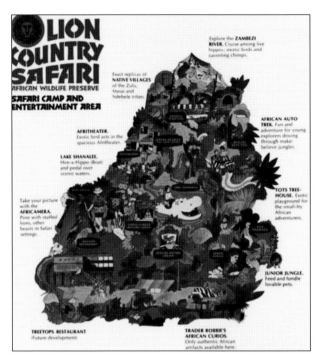

This map is from the beloved Lion Country Safari attraction, located in Irvine from 1970 to 1984. An ill and aging circus lion from Mexico was given to the facility, and he sired several litters of cubs—the result of having more than a few lionesses that were attracted to the lazy lion—earning him the nickname "Frasier the Sensuous Lion." Frasier became all the rage, drawing huge numbers of visitors to the Lion Country Safari. In 1973, Lion Country tried to capitalize on their new star, and a movie was made called *Frasier the Sensuous Lion*. T-shirts, watches, and other souvenirs were sold featuring Frasier until 1974, when he died and was buried on the grounds of the Lion Country Safari. Today a water park and amphitheater take up most of the property.

In 1962, the book *Orange County California, The Majestic Empire* detailed the history and attractions of the county. As nice as it sounds, "The Majestic Empire" never, to my knowledge, served as an official county slogan.

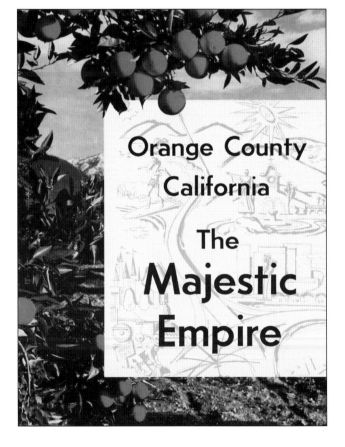

The dots on this 1932 map of Orange County indicate the Pacific Electric Railroad stops on lines that ran throughout the county.

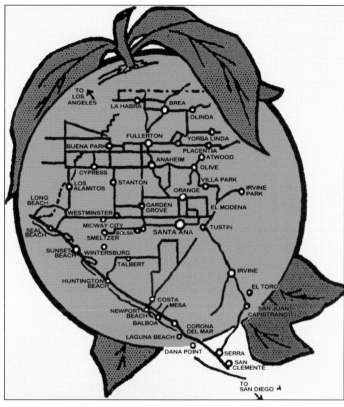

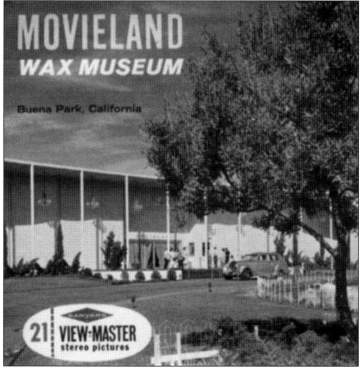

This View-Master image depicts the Movieland Wax Museum in Buena Park, opened in 1962 not far from Knott's Berry Farm. For decades, it was one of the most popular wax museums in the United States. Through its years, the museum added many wax renditions of famous show business figures, with several stars attending the unveilings. The building still stands, albeit empty. The museum closed its doors on October 31, 2005, after years of dwindling attendance.

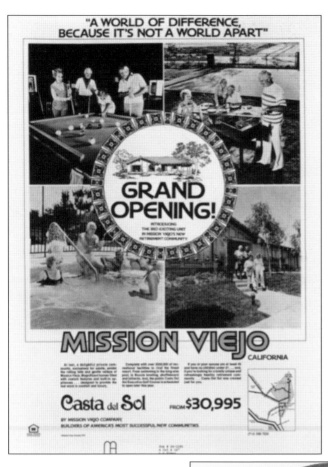

When Mission Viejo was first developed in the late 1960s, advertisements like this one promoting retirement homes from just over $30,000 painted a picture of fun, sun, and recreation. It is still open—nearly 2,000 homes strong—and features a golf course.

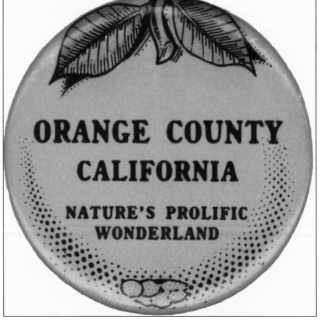

In the early 1920s, "Nature's Prolific Wonderland" was an adopted motto for the county. This picture shows a promotional button from that period.

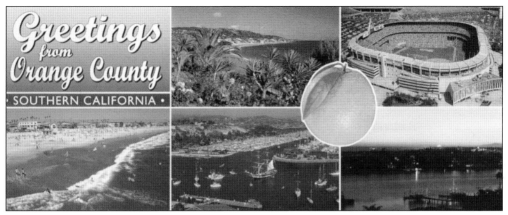

This postcard from the early 1990s incorporates images that have long been the selling points of Orange County: beaches, boating, beauty, and, of course, baseball.

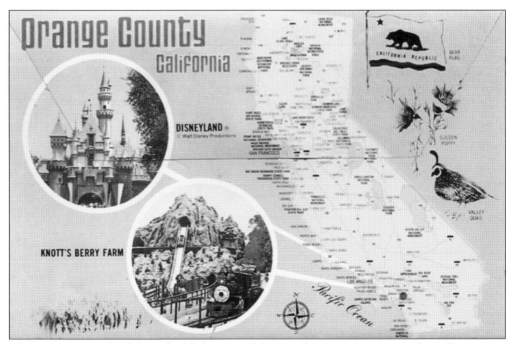

This 1960s poster of California highlights two of the most famous amusement parks in the country: Disneyland and Knott's Berry Farm.

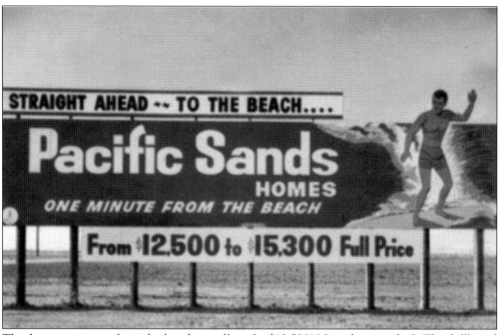

This home, a minute from the beach, is selling for $12,500? Now that is a deal! This billboard from the early 1960s advertises the Pacific Sands tract on Atlanta Avenue's 8100 block in Huntington Beach.

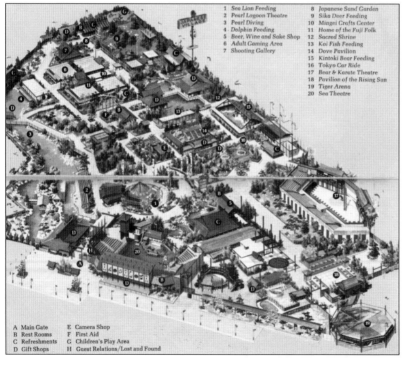

1	Sea Lion Feeding	8	Japanese Sand Garden
2	Pearl Lagoon Theatre	9	Sika Deer Feeding
3	Pearl Diving	10	Mingei Crafts Center
4	Dolphin Feeding	11	Home of the Fuji Folk
5	Beer, Wine and Sake Shop	12	Sacred Shrine
6	Adult Gaming Area	13	Koi Fish Feeding
7	Shooting Gallery	14	Dove Pavilion
		15	Kintoki Bear Feeding
		16	Tokyo Car Ride
		17	Bear & Karate Theatre
		18	Pavilion of the Rising Sun
		19	Tiger Arena
		20	Sea Theatre

A	Main Gate	E	Camera Shop
B	Rest Rooms	F	First Aid
C	Refreshments	G	Children's Play Area
D	Gift Shops	H	Guest Relations/Lost and Found

Deer roamed freely in the Japanese Gardens and Deer Park when it opened in the 1960s. Located in Buena Park, the attraction displayed various aspects of Japanese culture: pearl divers, koi ponds, shows, and so on. This is the map visitors received to help plan their day, before the park closed in the mid-1970s.

Four

BEACHES

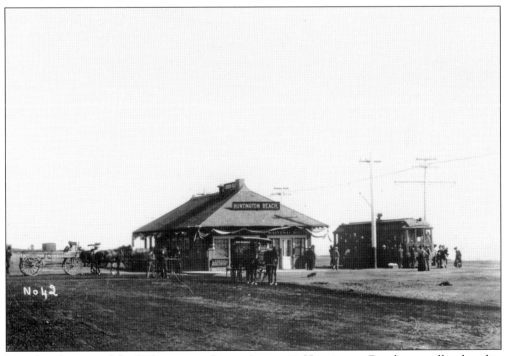

Just after the turn of the 20th century, Ocean Avenue in Huntington Beach was still only a dirt path, but they did have a Pacific Electric train station, thanks to Henry Huntington. The city of Huntington Beach is named in honor of this railroad magnate, who agreed to run his trains through town. The station was removed in the early 1940s.

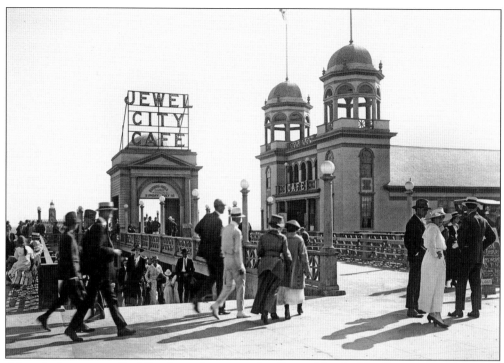

A hundred years ago, Seal Beach was known as the Coney Island of the West Coast, a bustling beach hot spot featuring temptations sure to lure even the most disciplined visitor. The Jewel City Café was a famous 1920s ballroom inn frequented by celebrities and other notable people of the era. After the Depression hit, the Jewel Café, a roller coaster, and some other seaside attractions fell into disrepair and were eventually closed and taken away. Though there is still a pier in this quaint little city, no sign of these structures exists.

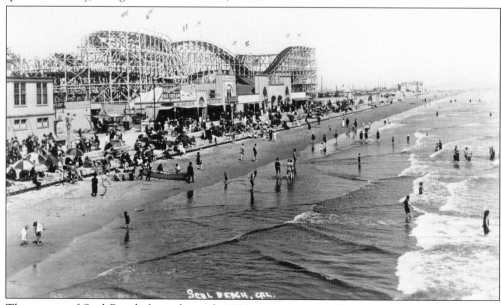

This image of Seal Beach from the early 1920s gives an even better idea of the carnival-like atmosphere that existed up and down the beach.

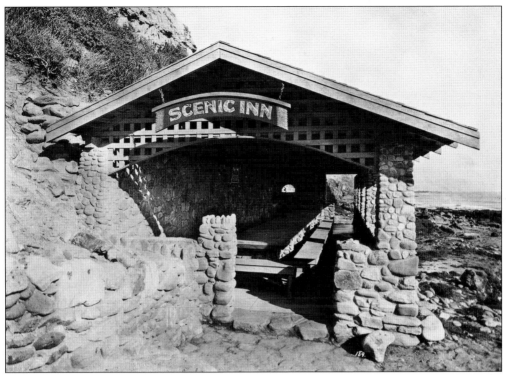

The Scenic Inn, located in Dana Point in the 1920s, was built of native beach rock at the base of the Dana Cove cliffs. Here hungry beachgoers could enjoy locally caught lobsters and spectacular views.

This shot of the Aliso Beach pier was most likely taken around the time of the pier's opening in 1971. In 1997, the pier was badly damaged by severe storms, and the entire structure was removed in 1999.

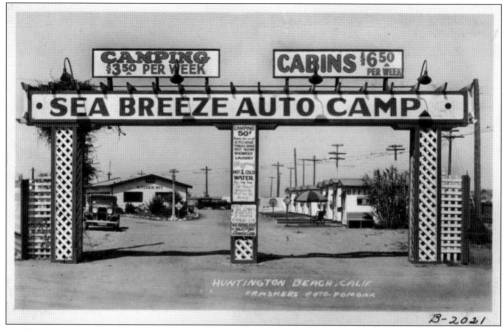

Back in the 1920s, near Coast Highway and Lake Street in Huntington Beach, one could rent a cabin at the Sea Breeze for just $6.50 per week. Camping was a mere $3.50 per week. Their bungalow-style auto court was just opposite the ocean and provided everything a weary traveler (or local) would want. Today the Sea Breeze is a memory, a faded postcard image.

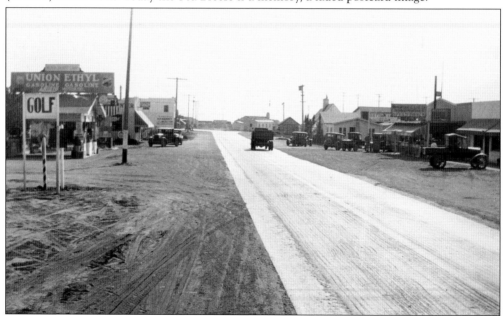

Capistrano Beach, while possessing its own zip code, is in fact part of the city of Dana Point. This area avoided much of the surrounding commercialization and is one of the few remaining beach towns in Orange County. Capo Beach, as it is called by many locals, is bordered by San Clemente to the south and Laguna Beach to the north, situated along the coast on the southern end of Dana Point. This image of Capo Beach dates back to 1930.

This is Corona Del Mar about 1939. Corona del Mar (Spanish for "Crown of the Sea") is a neighborhood in Newport Beach consisting of all land on the seaward face of the San Joaquin Hills south of Avocado Street to the city limits, as well as the development of Irvine Terrace, just north of Avocado. It is a very exclusive neighborhood today, but in this photograph, the area has hardly been developed at all.

Dana Point, shown here in the early 1920s, was named for Richard Henry Dana Jr., author of *Two Years Before the Mast*, which included a description of the area. He referred to Stillwater Bay (now Capistrano Bay) as the most "romantic spot on the coast." Dana had been traveling aboard the brig *Pilgrim*, which had to travel to California via Cape Horn and the stormy Strait of Magellan. It is still one of the most scenic places in Orange County.

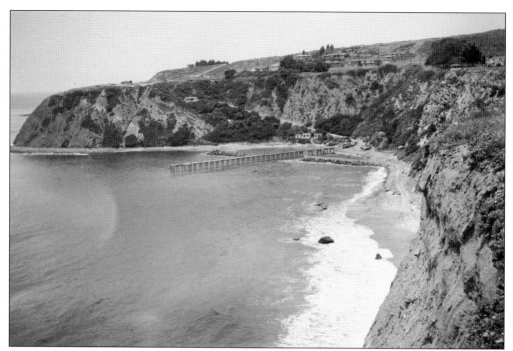

This undated photograph of Dana Point illustrates the rugged and private beauty of the area. Though it has been developed and become a popular place for tourists, Dana Point retains much of its natural beauty and appeal.

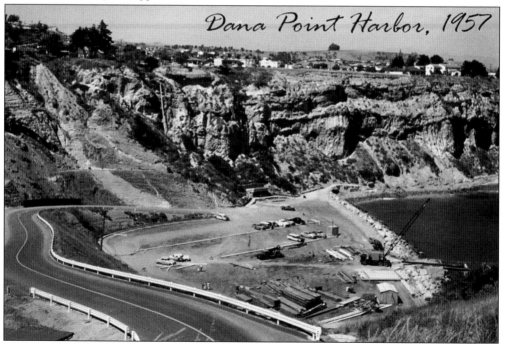

Dana Point Harbor, 1957

This 1957 Dana Point postcard shows some development in the harbor area where, today, there is an ocean research center and a replica of the *Pilgrim*, the 1830 schooner that Richard Henry Dana sailed on.

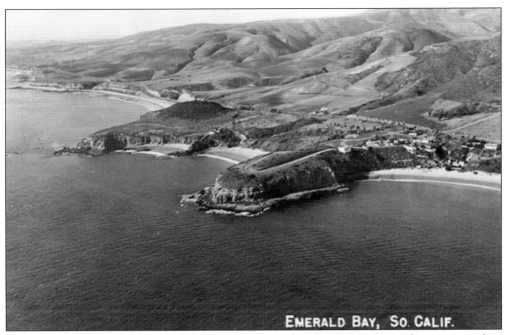

Emerald Bay is an exclusive part of Laguna Beach, and in this 1930s postcard image, it is clear many have yet to discover the pristine beauty of the area. Today, however, the hills are becoming more crowded and developed, and prices even for modest homes run well into the millions.

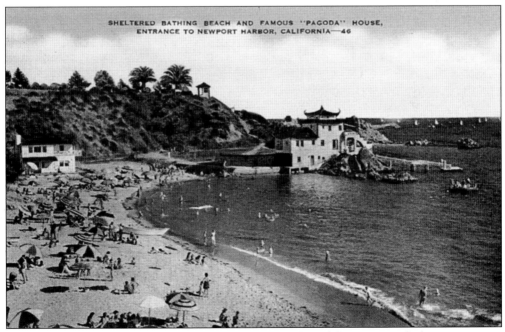

This 1944 postcard is captioned, "sheltered bathing beach and famous 'Pagoda' house, entrance to Newport Harbor, California." Also called the "China House," this structure stood near the mouth of the harbor for decades.

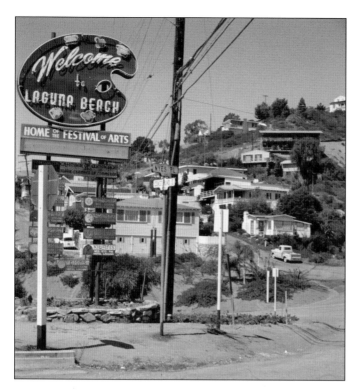

This is a welcome sign in Laguna Beach around 1956 promoting the well-known Festival of Arts in the art colony city. As a means to draw business back to Laguna after the Depression, the local Art Association had the idea of creating a summer festival held the week following the 1932 Los Angeles Olympics to lure visitors south to Laguna Beach before journeying home. The idea worked. A hit at the festival was the Living Pictures show created by artist and vaudevillian Lolita Perine. She dressed local residents in costume and seated them behind a makeshift frame. These tableaus fascinated viewers of all ages, and the tradition continues today.

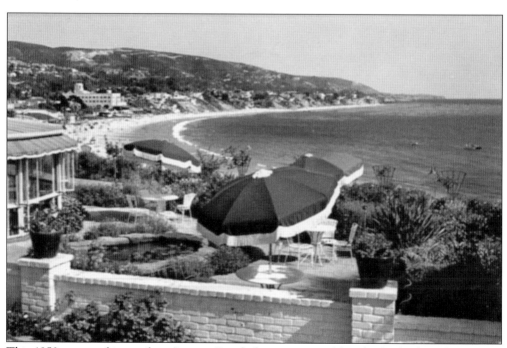

This 1950s postcard image from Laguna Beach depicts a typical beachside abode with gorgeous ocean views.

This sign from June 1968 depicting an artist's palette reads, "Laguna Beach, Riviera of the West." Smaller signs below promote various Laguna Beach community organizations. The palette design is a reflection of the artist culture in Laguna Beach.

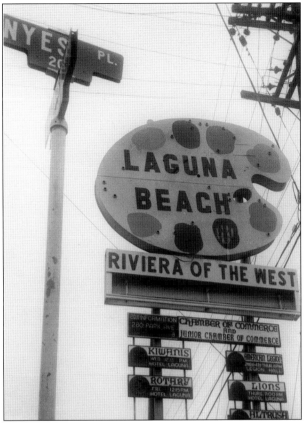

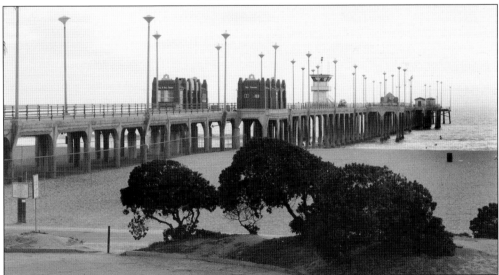

The pier at Huntington Beach has had its share of challenges from strong Pacific storms. This photograph shows the pier in about 1986, not long before it was hit hard by waves on January 17, 1988. The entire structure was closed on July 12, 1988, and completely rebuilt over the next few years, replicating the historic architectural style of the original 1914 concrete pier, complete with arched bents.

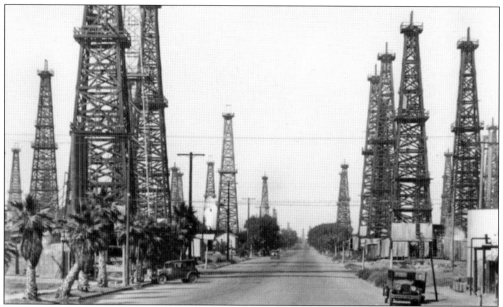

This 1920s photograph of Huntington Beach, looking north on Goldenwest Street, gives a good idea of just how much the discovery of oil changed the physical lay of the land. This beach town became an oil town, even though these wells were just a block away from the ocean.

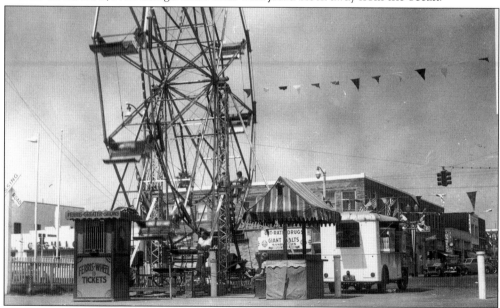

In 1947, Truman was president, the Yankees won the World Series, and big band music filled the air. Here in Huntington Beach, temporary amusement park rides and concessions have been installed to add a few thrills. Looking toward Main Street from the pier, folks are riding the Ferris wheel on what looks to be a lazy summer day. "Giant Malts" are available at the drugstore in the background and pennants flutter in the salty breeze. At left, a railroad crossing sign marks where the tracks once sat. The building on the far left (El Don Liquor Store) is still there, so is the building to the far right that now holds Perq's. Everything in between has been replaced—the ride, the train track, and the 5¢ malts.

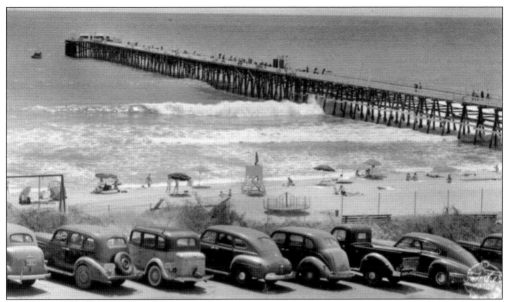

This is the San Clemente pier in 1948. In 1928, the 1,200-foot-long wooden municipal fishing and pleasure pier was constructed at no cost to local citizens. In 1939, and again in 1983, strong storms damaged the pier, requiring it to be rebuilt. Today a bait and tackle shop, a restroom, and a restaurant greet visitors at the entrance to the pier. The pier itself is located near the end of Del Mar Street.

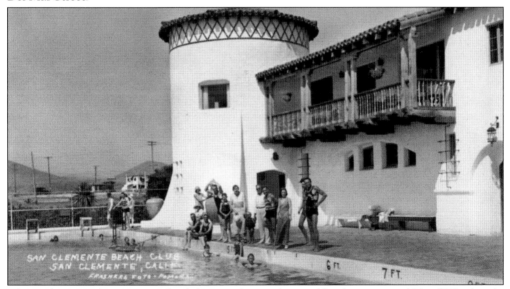

This is the San Clemente Beach Club around 1939, designed by the renowned Virgil Westbrook, who was responsible for most of San Clemente's first buildings. The club was built by contractor Roy Strang and dedicated in May 1928, just three years after the city was founded. It boasted an Olympic-sized pool and became the site for the 1932 Olympic tryouts. Champion swimmers and divers such as Johnny Weissmuller, Buster Crabbe, and Duke Kahanamoku were among those who swam here. The clubrooms have also been used for both civic and family events, including weddings, birthday celebrations, and meetings. Today it is called the Ole Hanson Beach Club, named for the famed real estate developer.

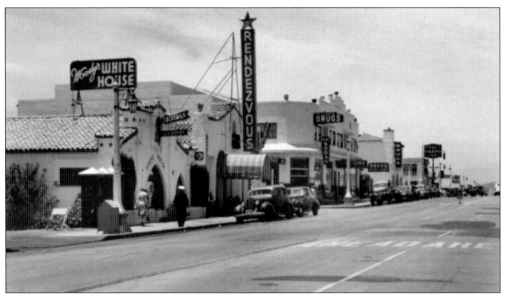

This 1930s image of the El Camino Real in San Clemente features a popular old haunt, Woody's White House Café, among several other establishments.

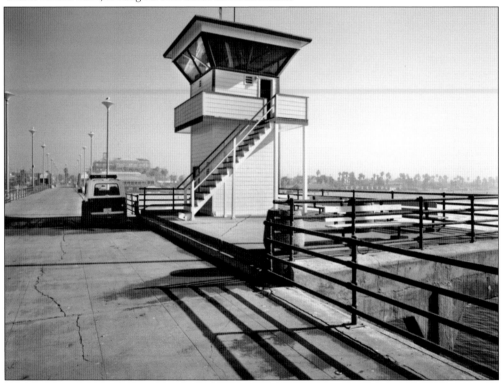

In 1989, the Huntington Beach Pier had been closed for almost a year after becoming structurally unsafe in the wake of El Nino's pounding 20-foot waves. The new pier would open in 1992 and, with it, a state-of-the-art "Tower Zero" for lifeguards to monitor the shores. But to catch a glimpse of that old tower, look toward the building supply company on Goldenwest Street near Garfield Avenue. The tower is there, tucked back among the stacked tiles and concrete.

Five

ATTRACTIONS
AND EVENTS

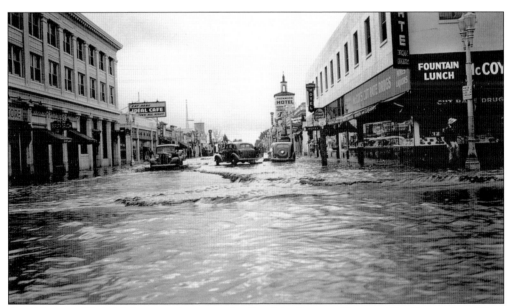

On February 27, 1938, heavy rains caused a flood in Orange County. The Santa Ana River spilled over its banks on March 3, sweeping away cars, homes, and bridges, including the Pacific Coast Highway. A total of 2,000 people were left homeless, and 19 people perished. As a result of this flood, the Prado Dam was built near Corona in 1941. Anaheim was hit particularly hard, as this photograph illustrates. The view here is South Los Angeles Street, later renamed Anaheim Boulevard.

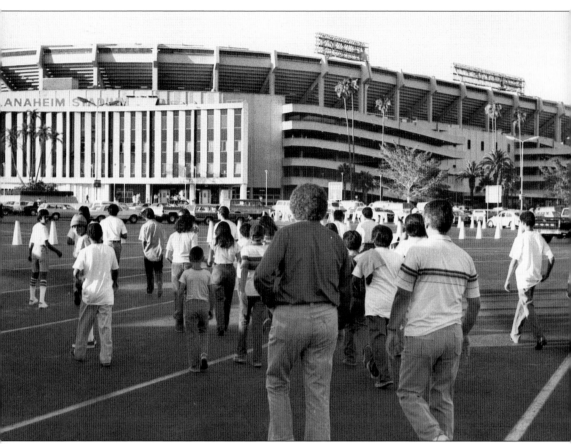

This is the exterior of Anaheim Stadium, 1980. Home to the Los Angeles Angels of Anaheim baseball team, the stadium was enclosed a year before this photograph was taken and then redesigned in 1998 to be open again in the outfield.

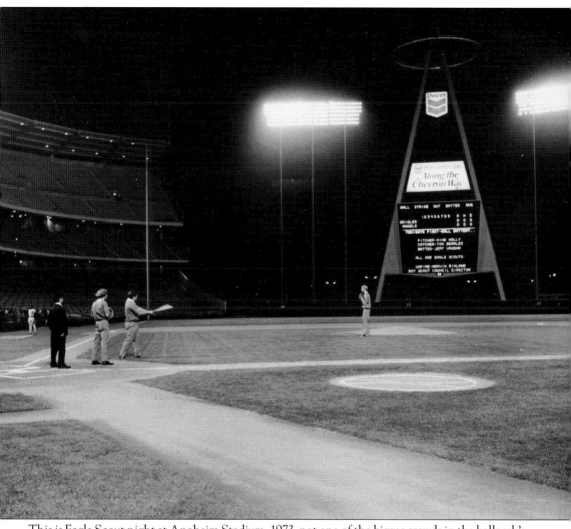

This is Eagle Scout night at Anaheim Stadium, 1973, not one of the bigger crowds in the ballpark's history. This was before the stadium was enclosed in 1979 (and later reopened in 1998).

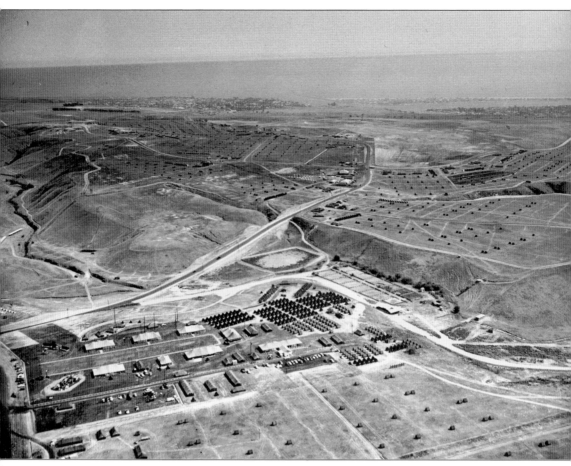

The first Boy Scouts of America National Jamboree was scheduled in Washington, D.C., in 1935 to celebrate the 25th anniversary of scouting in America. Unfortunately, the jamboree had to be canceled due to the prevalence of infantile paralysis (polio) in Washington. In 1937, the jamboree was held in D.C.; in 1950, it was held in Valley Forge, Pennsylvania; and then in 1953, it came to Irvine Ranch. The theme was "Forward on Liberty's Team," and 471,963 people attended.

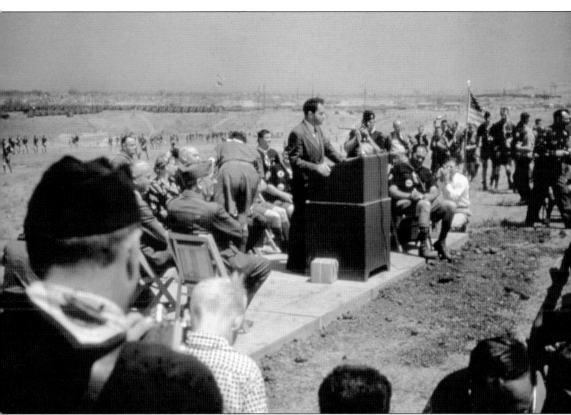

The Boy Scout Jamboree held July 17–23, 1953, was the first jamboree held west of the Mississippi River, and it was a huge moment for Orange County. The site of the jamboree is located where today's Newport Center and Eastbluff communities in Newport Beach now stand. In this photograph, then-vice president Richard Nixon speaks to the press at the jamboree.

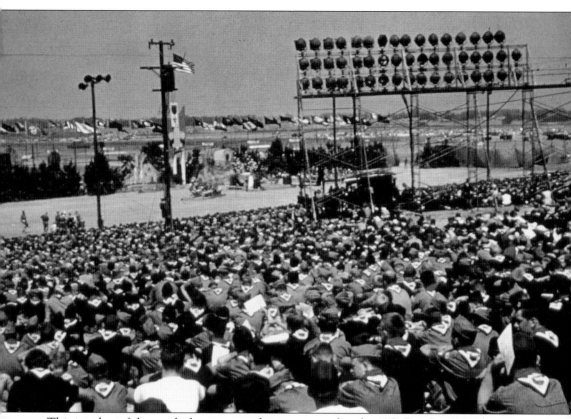

This is a shot of the amphitheater stage that was created at the 1953 Boy Scout Jamboree.

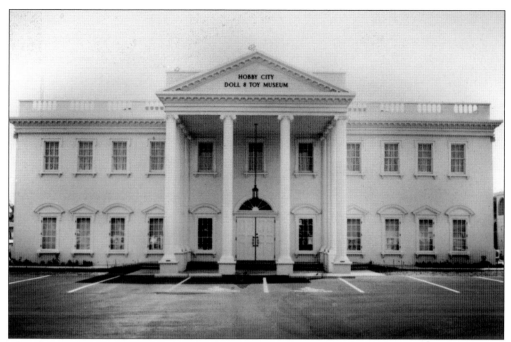

This shop and museum at the Hobby City Doll Museum on the Stanton/Anaheim border contains more than 6,000 distinct toys and dolls. Everything from Star Wars to Strawberry Shortcake can be found within its extensive collection. There are also plenty of rarities, including European dolls, all housed in a half-scale replica of the White House.

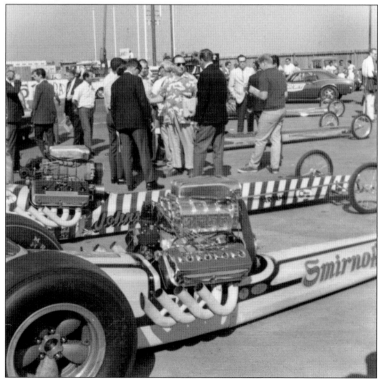

Back in the 1950s, a fellow named C. J. "Pappy" Hart created what is thought to be the world's first commercial drag strip, located at the old Orange County Airport (today called John Wayne Airport). It was called the Santa Ana Drag Strip and races took place there each Sunday. The drag strip was in business from 1950 to 1959, when it closed due to ever-increasing numbers of planes in the area.

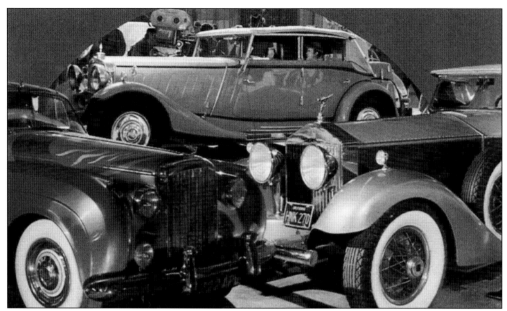

Movieworld in Buena Park dates back to the 1950s, when a family called the Bruckers started renting cars to Hollywood studios. In 1970, Jim Brucker and his son, Jimmy, opened Movieworld: Cars of the Stars and Planes of Fame Museum. They hired the famed Ed "Big Daddy" Roth to work for them designing and building sets and painting signs. The museum closed in 1979, but the Bruckers kept their collection of cars, as well as the largest private collection of artwork by Von Dutch, Roth, Williams, Ed "Newt" Newton, Dave Mann, and other originators of a style that would eventually be known as Kustom Kulture. Their items would eventually be sold at auction.

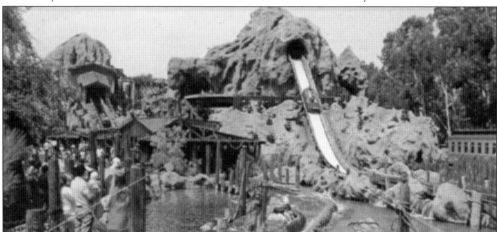

In the 1920s, Walter Knott and his family sold berries, berry plants, and pies from a roadside stand beside State Route 39 (Beach Boulevard) near the small town of Buena Park. In the 1930s, Knott was introduced to a new berry, developed by horticulturist Rudolph Boysen. The plant was a blend of the blackberry, loganberry, and the red raspberry. He planted a few of the hybrids he received on a visit to Boysen's farm and later sold them at their roadside stand. When people asked him what they were called, he said "boysenberries." The amusement park attractions at Knott's Berry Farm resulted from the family wanting to entertain guests waiting for Mrs. Knott's famous fried chicken dinners, which they began serving in the 1930s (and still serve). This postcard is from the 1970s.

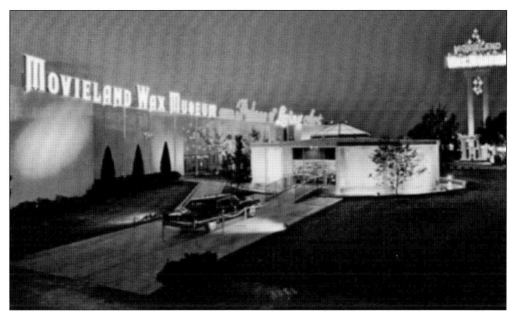

With over 300 wax figures in 150 sets, the Movieland Wax Museum, located in Buena Park, was the largest and one of the most popular wax museums in the United States. Allen Parkinson founded the museum on May 4, 1962, but sold it to the Six Flags Corporation in 1970. In turn, Six Flags sold Movieland on April 1, 1985, to Fong and Paul Associates, the owners of the world famous Wax Museum at Fisherman's Wharf. On October 31, 2005, after 43 years in business and 10 million visitors, Movieland closed. The structure still stands.

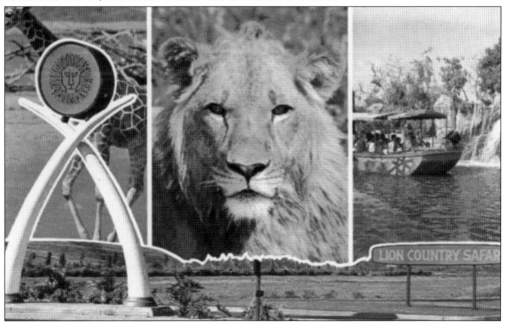

This is a 1970s postcard from Lion Country Safari in Irvine, which ran from 1970 to 1984. After the park's closing, certain parts were maintained as a camp, which still exists (as do a few of the rolling hills, which have yet to be developed). Much of the rest of Lion Country was replaced by a water park and amphitheater.

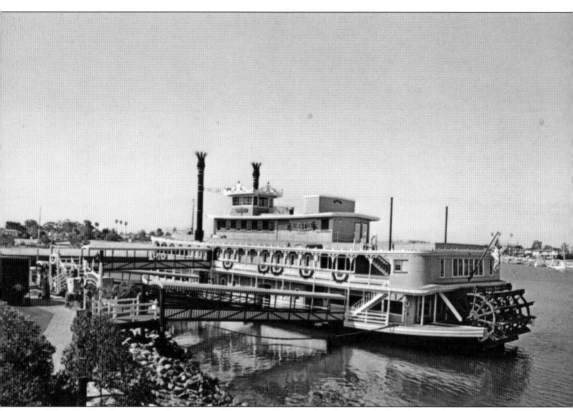

The *Rueben E. Lee* riverboat sat in Newport Harbor for 43 years before being demolished in 2007. Designed and built in 1963 by Blurock and Associates, the riverboat opened as the Reuben E. Lee restaurant the following year. Over time, the restaurant changed hands, becoming a Charlie Brown's Steakhouse and later, the Riverboat Restaurant. In 1995, the Newport Harbor Nautical Museum moved aboard, and the boat was renamed the *Pride of Newport*.

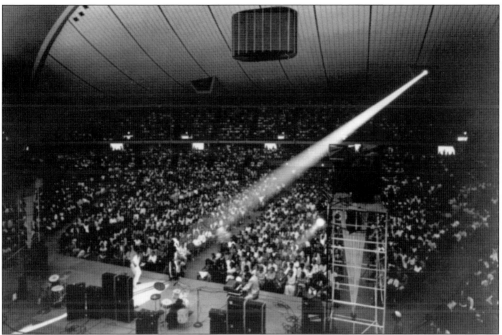

On July 15, 1967, 8,500 people turned out to see The Doors performed two shows at the Anaheim Convention Center with Jefferson Airplane. Jim Morrison is visible downstage in this photograph.

This is a ticket to the Golden Bear nightclub in Huntington Beach, located in a brick building at 306 Pacific Coast Highway. This nightclub, which possessed a large dining and music hall, is remembered as a local treasure. This ticket dates back to the early 1980s; the club closed soon after that.

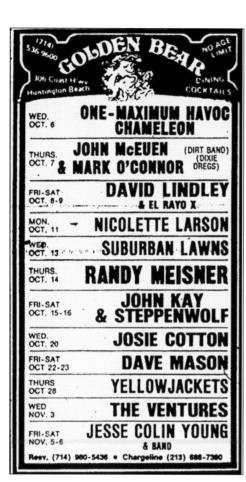

This late 1970s advertisement gives an idea of the caliber of artists that performed at the Golden Bear over the years. In its heyday, the Golden Bear played host to Jimi Hendrix, Janis Joplin, Linda Ronstadt, and many other musical legends.

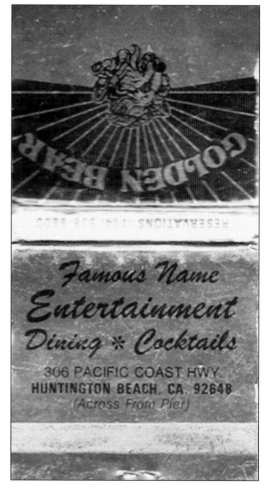

This is an old matchbook from the Golden Bear. Opened as a restaurant in the 1920s, the Bear was designed by renowned Southern California architect Ernest Ridenour, and movie stars would motor down from Hollywood for dinner at the club after a day on the beach. By the early 1960s, the space morphed into a music club. The Doors played the Bear, along with many other musicians and musical groups. The building was demolished in the 1980s, and today there's a hot dog place at the site.

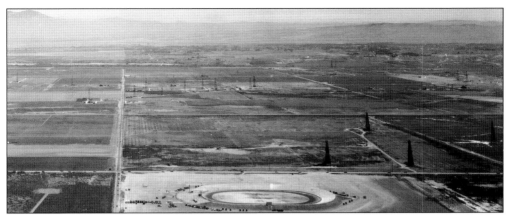

This is Talbert Stadium in Huntington Beach about 1950. From 1946 until 1959, this was the site of popular jalopy and midget auto races. Today, located near the intersection of Atlanta Avenue and Beach Boulevard, the site has been residentially developed. In this photograph, but for a few oil wells, the area is blissfully open.

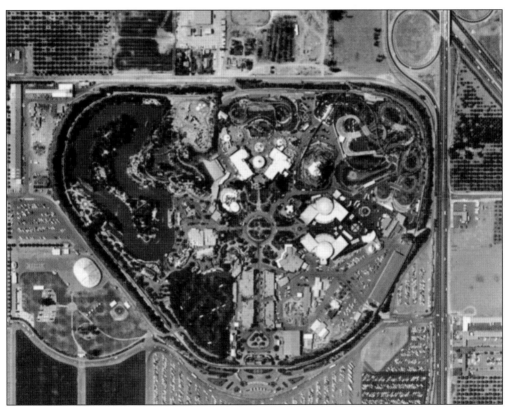

This is an aerial view of Disneyland in Anaheim around 1960. Disneyland opened on July 17, 1955, in ceremonies led by Walt Disney. Currently, more than 515 million guests have visited the park since it opened, including presidents, royalty, and other heads of state. In 1998, the theme park was renamed Disneyland Park to distinguish it from the larger Disneyland Resort complex. In 2007, over 14,800,000 people visited the park, making it the second most visited park in the world.

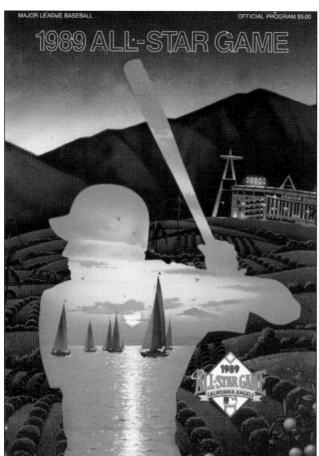

MAJOR LEAGUE BASEBALL OFFICIAL PROGRAM $5.00

1989 ALL-STAR GAME

The 1989, the MLB All-Star Game in Anaheim featured one of the most versatile athletes in Orange County history. Bo Jackson was a standout player for the National Football League (NFL) as well as Major League Baseball (MLB), and it is believed by many that if his career had not ended so early, he could have been one of the greatest players in both sports. This Midsummer Classic is remembered for Bo Jackson's monstrous lead-off home run to center field, as well as for the designated hitter position being allowed in an all-star game for the first time. This was also the final all-star appearance for two legends: Hall of Fame manager Tommy Lasorda and Hall of Fame pitcher Nolan Ryan. The American League defeated the National League 5-3. This is a program from that game.

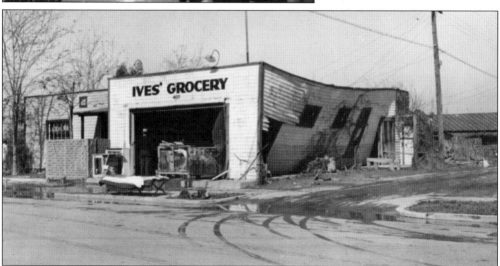

Ives' Grocery Store in Anaheim, like many other homes and businesses, was severely damaged by the 1938 flood. This view is looking northwest of Ives' Grocery store at 407 East North Street. The image shows the east wall, which collapsed following the flood. Also visible is an unidentified man (perhaps Bruce B. Ives) surveying the damage done by this terrible event.

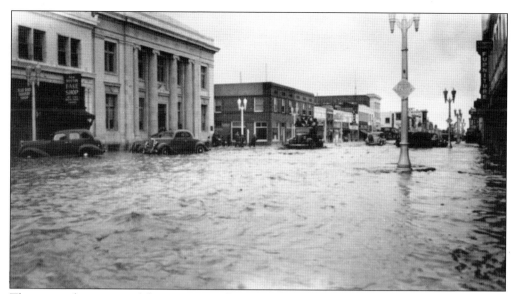

This is another image of downtown Anaheim after the 1938 flood hit. The view includes the front facade of the third city hall building (1923–1980), located at 204 East Center Street (now Lincoln Avenue), along with graphic evidence of floodwater running through the street and over the sidewalks.

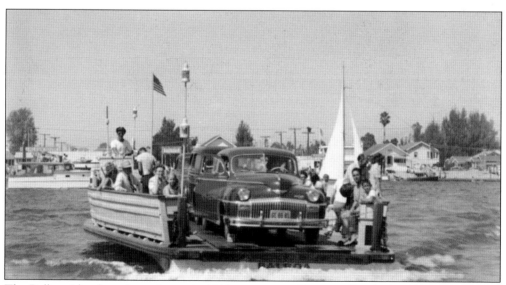

The Balboa Island car ferry, shown in 1948, operates in Newport Beach. Joseph Beek obtained the rights in 1919 from the City of Newport Beach to provide this ferry service from Balboa Island across the Newport Harbor to the Balboa Peninsula. The boats travel under 1,000 feet round-trip, reaching a top speed of four miles per hour. The speed limit in the harbor is five miles per hour, and the ferry docks about every five minutes. A full-time captain will dock the ferry at least 22,500 times every year, traveling at least 3,200 miles every year. The business is still in the family today and rides cost $1 per passenger, $1.25 with a bike, and car and driver are $2.

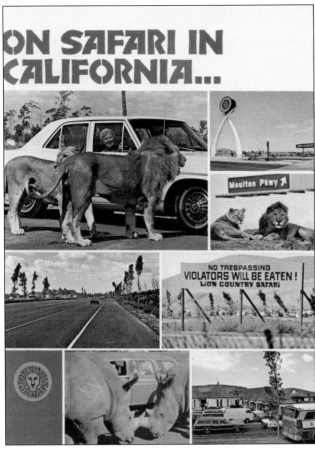

This is a program cover from Lion Country Safari in Irvine. Though the park has been closed since 1984, it is possible to find remnants of this attraction when walking through the abandoned area. Traces of old safari roads still exist in the hills where animals used to roam.

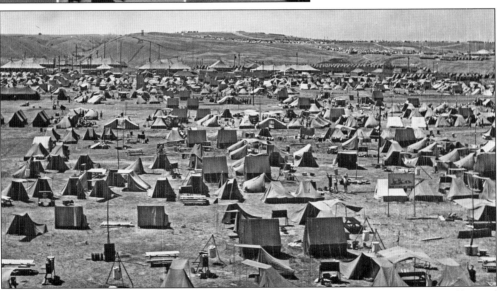

This is another image from the famed 1953 National Boy Scout Jamboree. A number of Hollywood stars, including Bob Hope, Danny Kaye, Debbie Reynolds, Dale Evans, Roy Rogers, and Roy's horse, Trigger, made the trip to the jamboree to entertain scouts and their guests.

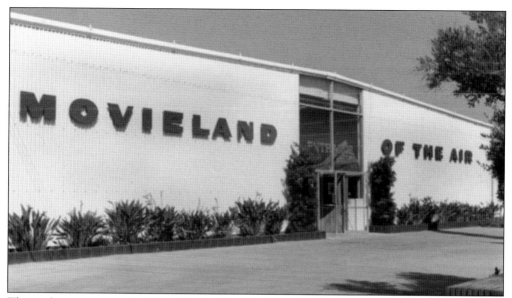

This is the entrance to the Movieland of the Air Museum, which was located at the old Orange County Airport (today John Wayne Airport). Opened in 1963 by veteran movie pilots Paul Mantz and Frank Tallman, it featured a large collection of historic airplanes. It remained popular through the 1960s, but attendance began to dwindle in the 1970s. Company president Frank Pine died in 1984, and action was taken by the surviving members of the original owners' families to liquidate the collection and sell the company. Most of the museum collection was sold to Kermit Weeks in Florida, where much of it remains on display in the renowned Fantasy of Flight museum. Movieland of the Air officially closed in 1985.

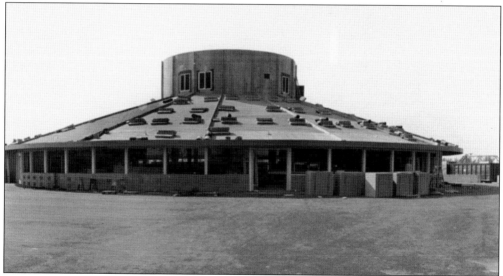

This is a view of the Melodyland Theatre under construction in 1963. Located at 400 West Freedman Way (originally 10 West Freedman Way) in Anaheim, this was Southern California's first theater-in-the-round. This $1.5-million theater was built by producers Sammy Lewis and Danny Dare and opened with *Annie Get Your Gun* on July 2, 1963. Many concerts and events were held throughout the 1960s, but in 1969, the building was purchased by Rev. Ralph Wilkerson and reopened as the Melodyland Christian Center. The building was demolished in 2003.

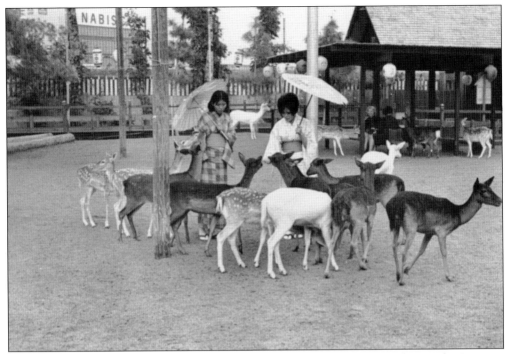

In this mid-1960s image are young women in Japanese costume feeding the deer at the Japanese Gardens and Deer Park, the old Nabisco plant visible in the background on the left. This attraction opened in Buena Park in the 1960s and lasted until the mid-1970s. In addition to the many deer roaming the property, the park featured Japanese Pearl divers, cultural Japanese shows, koi ponds, and other elements relating to Japanese culture.

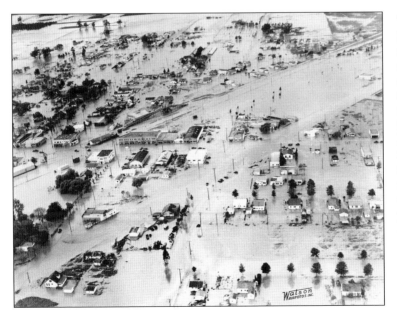

This aerial view of Buena Park during the tragic flood of 1938 provides a real sense of the devastation that took place. When the Santa Ana River roared past its banks after five steady days of rain, more than 50 people died, including 43 victims at a Mexican settlement in Atwood. The 1938 flood remains Orange County's worst natural disaster to date.

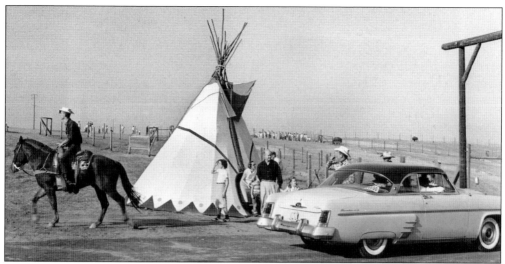

The old Buffalo Ranch was a beloved tourist attraction that sat on about 115 acres in Newport. Owned and operated by Gene Clark, great-grandson of the famed American Indian chief Geronimo, the ranch opened in the 1950s with about 70 buffalo and soon grew. Native American families from Kansas were even invited to live and work at the ranch to create some authenticity. When the attraction closed in the 1970s, the buffalo were shipped off to Catalina. The statue that is passed on MacArthur today was placed in honor of Buffalo Ranch, which was located just behind the statue. (Bison Road was originally created as an access road to the Buffalo Ranch.)

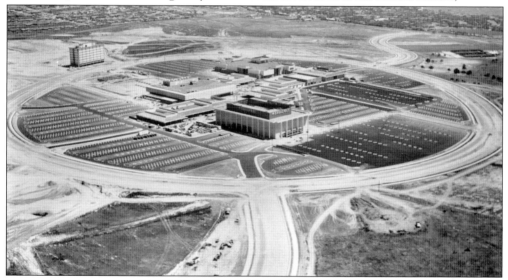

Fashion Island was opened in 1967, the year of this photograph, as part of Newport Center. The mall featured four department stores: Buffum's, J. W. Robinson's, The Broadway, and J. C. Penney. These four initial buildings were designed by architects William Pereira and Welton Becket and were flanked by several smaller stores. A few years later, Bullocks Wilshire (which later became I. Magnin) and Neiman Marcus were added. In the early 1980s, J. C. Penney moved out, and the building it occupied was reconstructed as "Atrium Court," which contained numerous smaller shops and a food court on the lower level. The southwest entrance to Robinson's features a bronze wind chime sculpture by artist Tom Van Sant, installed in September 1967, recorded by Guinness World Records as the largest wind chime.

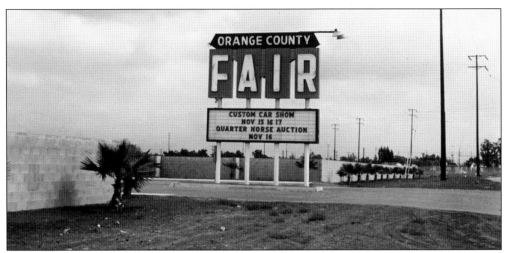

This is the Orange County Fairgrounds, pictured in 1963. The first Orange County fairs (in the 1890s) were primarily livestock exhibitions and horse races. At the turn of the century, a "carnival of products" was added, and the fair became an annual event, held each year in Santa Ana. After World War I, it was moved to Huntington Beach for two years and then back to temporary grounds on East Fruit Street in Santa Ana. The fair was first held at the site pictured here in Costa Mesa in 1949, and it soon was designated as the permanent fairgrounds. In 1953, the City of Costa Mesa was incorporated, and the new city included the fair's location. From 1949 to today, the wonderful Orange County Fair has blossomed from a small, community, five-day celebration to a massive 21-day extravaganza and one of Southern California's most eagerly awaited annual events.

This is the old California Alligator Farm. Next door to the Los Angeles Ostrich Farm in Lincoln Heights, it started as the Los Angeles Alligator Farm and was a wildly popular tourist destination from 1907 to 1953. The attraction received its new name—the California Alligator Farm—when it moved to Buena Park. The farm, which also featured snakes, tortoises, and other reptiles, remained open until 1984, at which point the animals were shipped to a private estate in Florida. The former Beach Boulevard location is now a Claim Jumper restaurant.

Six

NOTABLE PLACES

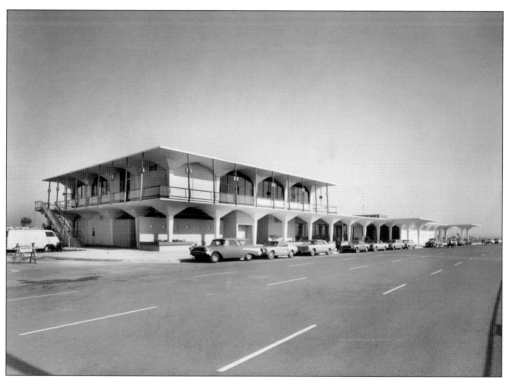

John Wayne Airport originated as a private landing strip, built on Irvine Company land in the 1920s by aviation pioneer Eddie Martin. In 1923, Martin founded a flying school and Martin Aviation, one of the nation's oldest aviation firms. John Wayne Airport became a publicly owned facility in 1939 through a land swap between the Irvine Company and the County of Orange. After serving as a military base during World War II, it was returned by the federal government to the county with the stipulation that it remain open to all kinds of aviation. The 22,000-square-foot Eddie Martin Terminal, seen here in 1967, was built the same year to accommodate 400,000 annual passengers.

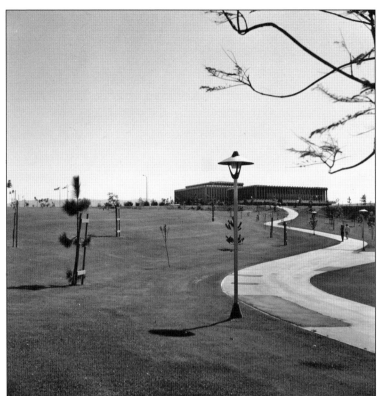

The University of California, Irvine was founded in 1965. It is the second youngest University of California campus and is widely recognized as UCI or UC Irvine. This image of the university dates back to 1966, when there was still plenty of open space.

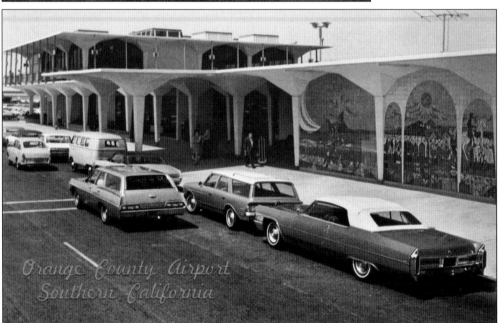

This is another image of John Wayne Airport, taken in the late 1960s. Originally named Orange County Airport, the county Board of Supervisors renamed it in 1979 to honor the late John Wayne, who resided in nearby Newport Beach and had died earlier that year. A statue of the airport's namesake welcomes travelers passing through the arrivals area on the lower level.

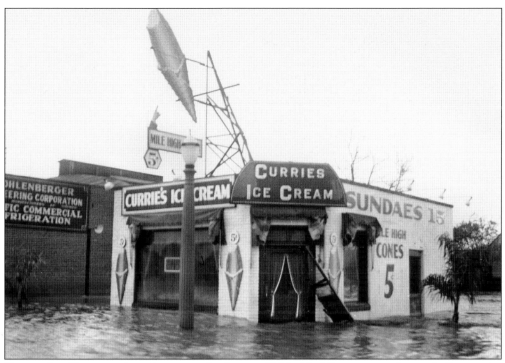

Curries Ice Cream parlors, featuring the famous "Mile High" cone, were located all over the county. This Anaheim parlor paid a huge price in the flood of 1938.

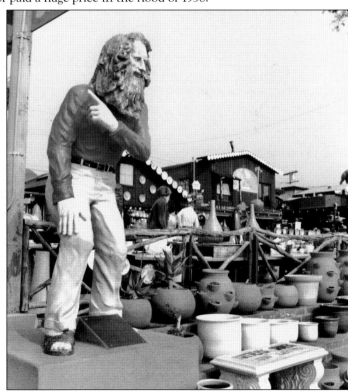

One famous aspect of the art colony known as Laguna Beach is the concept of town greeters. The first greeter, active during the 1880s, was named Old Joe Lucas, but the best known was a Dane named Eiler Larsen, christened "Official Greeter and Goodwill Ambassador" in 1963. Larsen stood by the road for four decades waving and shouting greetings to visitors. He died in 1979, but Larson was so popular a statue of him was erected in front of the local Pottery Shack, where this photograph was taken in 1965. The statue is still there, and another just like it stands nearby on the Pacific Coast Highway.

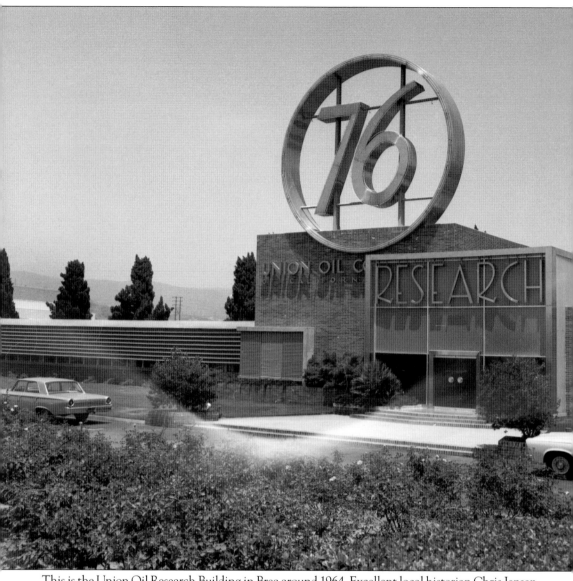

This is the Union Oil Research Building in Brea around 1964. Excellent local historian Chris Jepsen encourages everyone to "dig those clean, modern lines, and the wonderful signage. I bet it was hard to take a bad photograph of this place since the 'good composition' was built right in. Naturally, the eye is immediately drawn to the huge 76 circle, but ultimately, the word 'RESEARCH'—in a font mimicking architects' printing—is even cooler. There are a lot of contrasting textures used in this building too, which was typical of the era. Today, industrial buildings (like everything else) tend to just look like stucco crates."

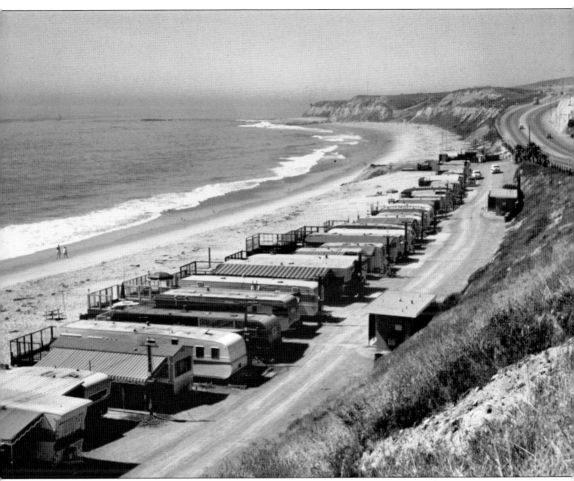

El Morro Village was one of Southern Orange County's oldest communities. What began as a beach campground and abalone stand in 1927 (the same year Laguna Beach became a city) grew into a residential community housing nearly 300 families and was one of the last affordable neighborhoods along the Orange County coast. Originally called Tyron's Camp, it was renamed El Morro Camp in the 1930s, and by the 1940s, tent camping was replaced with trailers. By 2001, El Morro Village was surrounded along the coast by multimillion dollar homes, and in 2006, the old community was dismantled. This image is from 1956.

The Tustin Marine Corps Air Station (seen here in 1968) was established in 1942 as Santa Ana Naval Air Station, a base for airship operations in support of the U.S. Navy's coastal patrol efforts during World War II. NAS Santa Ana was decommissioned in 1949. In 1951, the facility was reactivated (as the Tustin Marine Corps Air Station) to support the Korean War. It was the country's first air facility developed solely for helicopter operations. The base ceased operations in 1999.

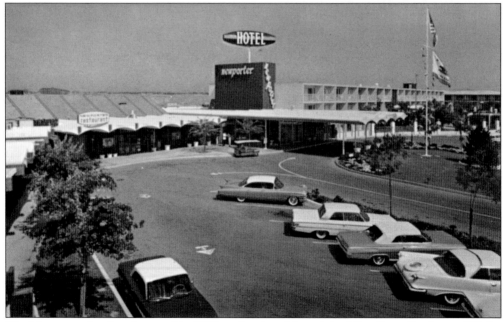

The Newporter Inn hotel opened in 1962 on the site of the original Boy Scout Jamboree. While, at one time, it was a hot spot for Hollywood celebrities and a hangout for John Wayne, it fell into disrepair. Recently, it was given a makeover and became the Hyatt Regency Newport Beach.

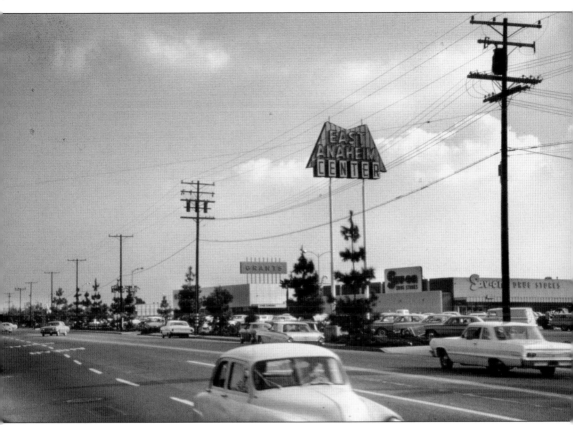

This is the East Anaheim Shopping Center, located at 2180 East Lincoln Avenue in Anaheim. Opened in 1966 (the year this image dates from), it originally included a Sav-on Drugs and a Grants department store. The shopping center still stands.

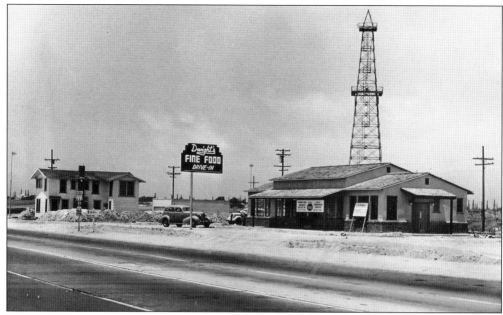

The success of Dwight Clapp's beachside concession in Huntington Beach allowed the Clapps to open Jack's Fine Food Drive-In, located at Pacific Coast Highway and Beach Boulevard. It was open from 1948 to 1955 and, while it became the hot spot after high school football games, it was also popular with celebrities. Dwight's son Jack (who worked here) said it was a favorite haunt of the actor Ray Milland.

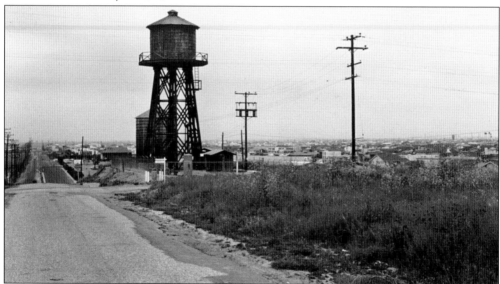

The Los Patos water tower in Huntington Beach was built in 1939 and situated on the bluff near Warner Avenue overlooking the Pacific Coast Highway and the wetlands. As historian Chris Jepsen detailed, "Los Patos was a stop for the Pacific Electric's 'Red Cars' and served mainly as a drop-off point for hunters on their way to the area's many duck clubs. ('Los Patos' means 'the ducks' in Spanish.) Until sometime in the 1960s, the stretch of Warner Avenue between the bluffs and the beach was also called Los Patos Street. In fact, at the top of the bluffs, a small stretch of Los Patos Street still remains."

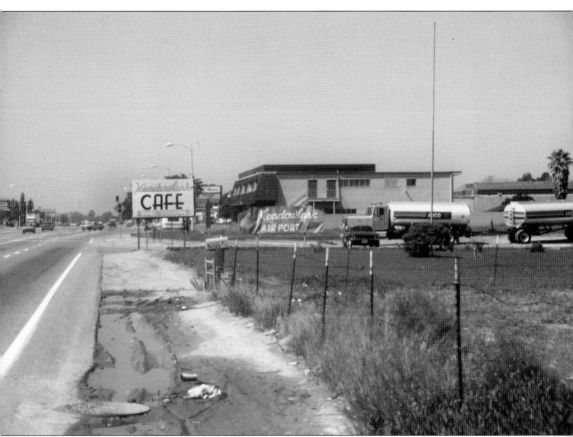

Meadowlark Airport was a small operation in Huntington Beach about a mile east of the Pacific Ocean. Opened in the early 1950s, Meadowlark hosted a number of different businesses at various times, including the Meadowlark Cafe, Harbor Aviation, Sky Ad, Joe Hughes Air Shows, and assorted small shops. The narrow, 20-foot-wide landing strip was allowed to languish until the late 1970s, when potholes were filled and the runway repaved. When Meadowlark closed for good in 1989, the area was redeveloped into the Summerlane community, a mixed-use commercial and residential development. This image is from the late 1970s.

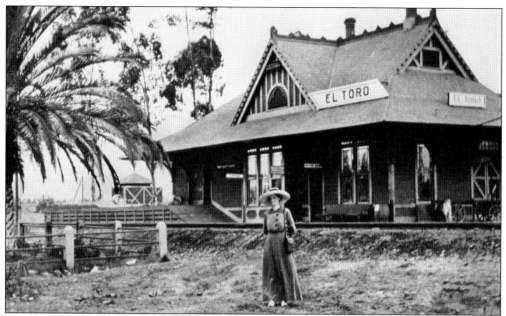

In 1884, a Bostonian named Dwight Whiting bought the Rancho Canada de Los Alisos and developed it as an English village named Aliso City (later called El Toro/Lake Forest). It is said when railroad officials asked Mrs. Dwight Whiting to name the station at this site, she selected the designation El Toro from a bull that had recently drowned in a nearby well. (El Toro means "bull.") Not sure if this is Mrs. Whiting, but it is the old El Toro station.

In 1940, Walter Knott started to create the Living Ghost Town at Knott's Berry Farm, providing free entertainment to dinner guests. A few years later, he purchased the Calico ghost town in San Bernardino County so he could add some actual historic artifacts. This is the ghost town schoolhouse, a favorite among visitors.

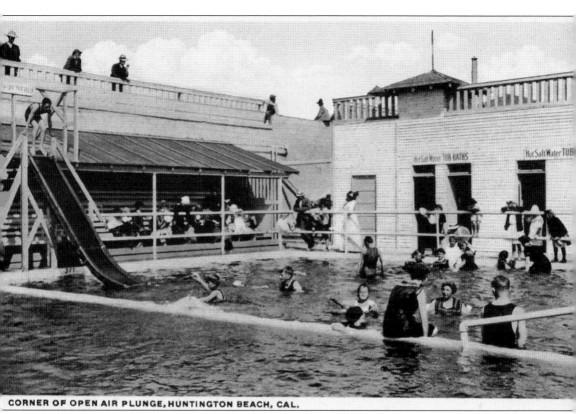

CORNER OF OPEN AIR PLUNGE, HUNTINGTON BEACH, CAL.

In 1910, the city of Huntington Beach built the famous saltwater plunge at the foot of the pier. Plunges were popular in cities all along the coast, providing the option of heated water near the sometimes-cool coastal waters. This postcards dates to 1914.

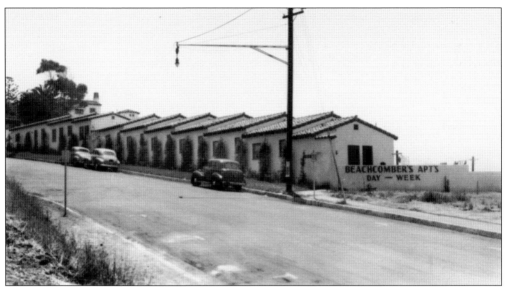

Located at 529-533 Avenida Victoria in San Clemente, the Beachcomber Motel is believed to be the oldest continuously running business in the city. According to historian Chris Jepsen, it is one of only a few examples of Spanish Colonial Revival–style motels located on a coastal bluff. This image is from 1948.

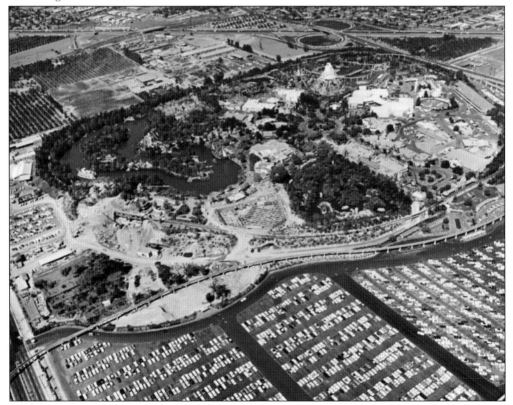

In this 1967 aerial view of Disneyland, citrus groves can be seen to the left. Today, of course, they are gone.

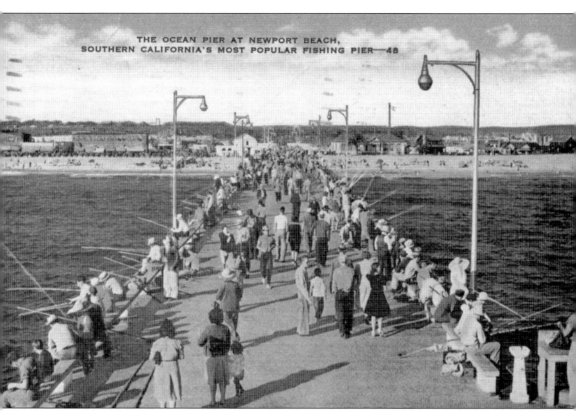

THE OCEAN PIER AT NEWPORT BEACH,
SOUTHERN CALIFORNIA'S MOST POPULAR FISHING PIER—48

The Newport Pier is one of two piers located within the city of Newport Beach, California, at the western end of the Balboa Peninsula. It is 1,032 feet long and registered as California Historical Landmark No. 794.

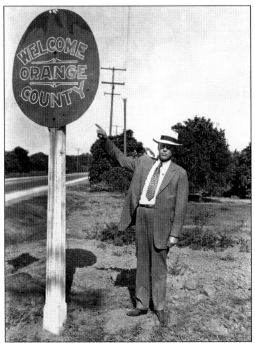

Scant details are available on this photograph, which local historian Phil Brigandi thinks may have been taken on the north/west end of the county, as it is where one would find flat ground and orange groves at the county line. Could that sign still exist and possibly be in some civic center storage room?

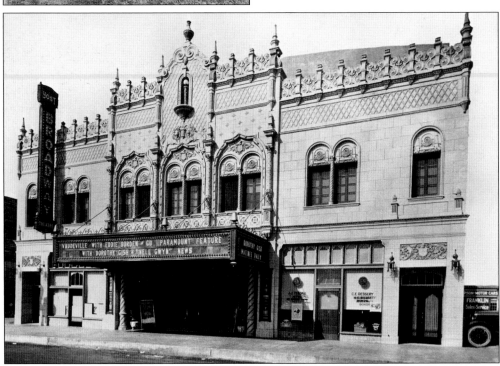

Santa Ana's beautiful Broadway Theater opened in 1926, designed by architects Carl Boller and A. Godfrey Bailey. A fire in 1952 caused massive damage to the theater, but it was rebuilt and opened again in 1955. The Broadway closed for good in 1987, and in 1989, another fire destroyed much of the theater. A year later, the structure was demolished. This image dates back to the mid-1920s.

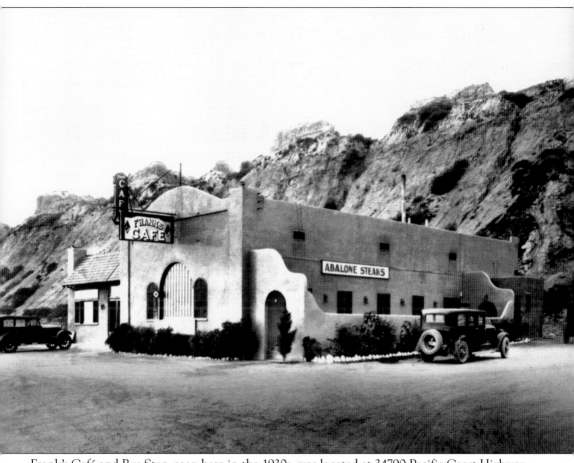

Frank's Café and Bus Stop, seen here in the 1930s, was located at 34790 Pacific Coast Highway in Capistrano Beach. It became the Palisades Café in the 1940s but went out of business in the late 1950s.

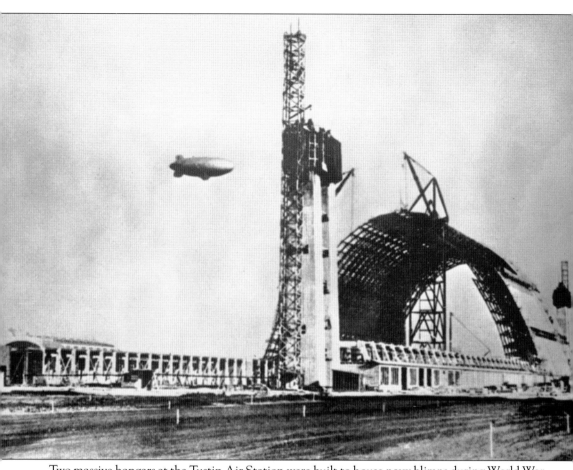

Two massive hangars at the Tustin Air Station were built to house navy blimps during World War II. At 1,000 feet long, the hangars could hold several blimps each. Their use for this was brief, however, as blimps were taken out of active service by 1950. The 1,600-acre base evolved into the largest Marine Corps helicopter base in the country before it closed in 1999. Though it is still standing, the hangars' collective fates have yet to be decided (and a mega mall has opened right next to them). This 1942 U. S. Navy photograph shows Tustin's Hangar No. 1 under construction, a blimp flying overhead.

The Independent Order of Odd Fellows (IOOF) is a fraternal organization derived from English Oddfellows orders of the mid-1700s. The Odd Fellows Hall at 309-311 North Main Street in Santa Ana is on the National Register of Historic Places.

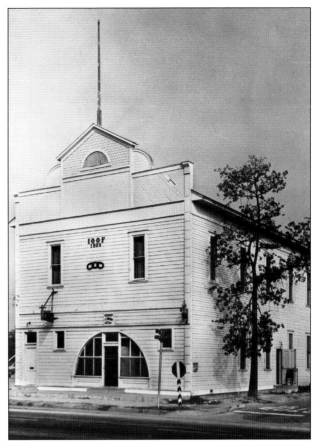

This image was shot in the city of Orange, looking north up Glassell toward the Plaza from Almond in the 1960s.

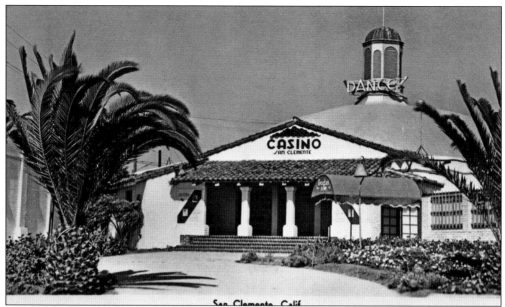

The San Clemente Casino and Dance Hall located at 100 and 140 Avenue Pico opened July 31, 1937. "Where the song of the surf blends with the cool breezes of the sea" was their motto, and that opening night attracted some 5,000 people from all over Southern California. (San Clemente's total population was only 250.) Judy Garland, who had just finished *The Wizard of Oz*, often came down from Hollywood, as did Mickey Rooney, Dorothy Lamour, Vivian Leigh, Cesar Romero, Pat O'Brien, and many others. The building is under restoration.

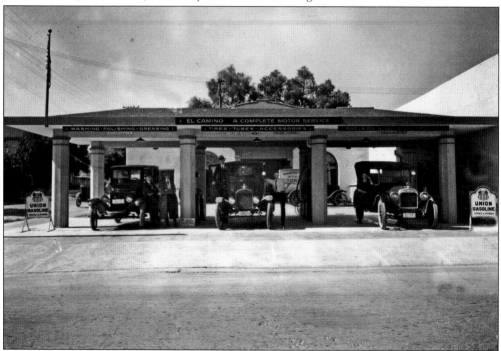

This is the El Camino Motor Service Station in San Clemente around 1920. Notice how all of the motorists are posing for the photograph.

This image shows the now-defunct San Juan Capistrano Hot Springs in the early 1960s. In addition to the natural hot springs, there was also a swimming pool, presumably where one could cool down after all the hot spring water.

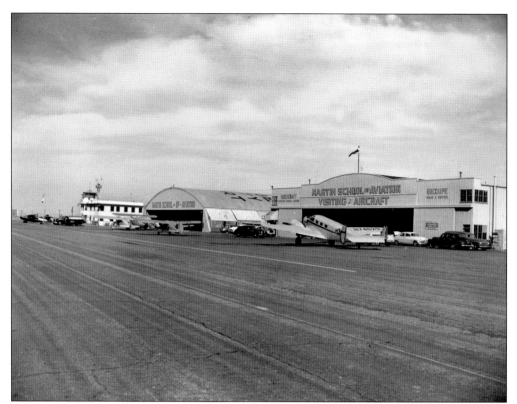

This image from the 1950s depicts the Martin School of Aviation hangers at the Orange County Airport. The white building on the left is the airport's administration building. Various airplanes are visible, as well as automobiles.

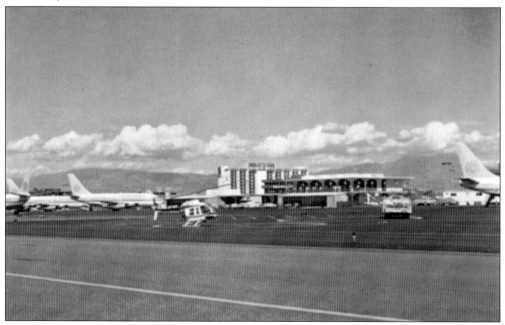

This postcard image is from the Orange County Airport in the early 1970s.

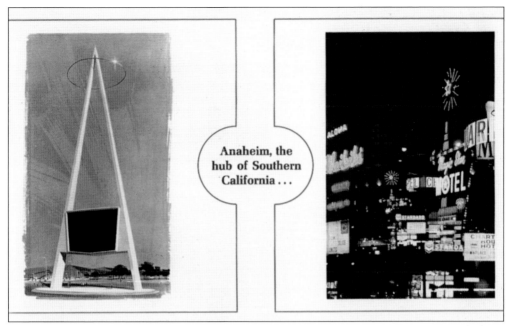

This mid-1960s promotional flyer optimistically describes Anaheim as the "hub of Southern California."

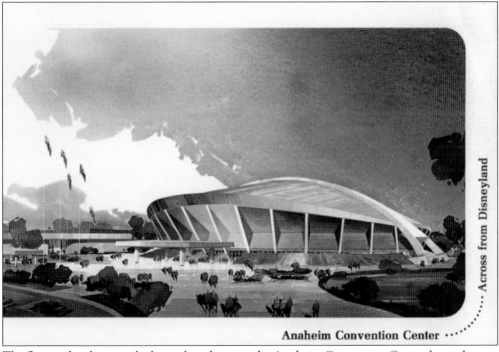

The flyer in the photograph above also advertises the Anaheim Convention Center, located across from the Disneyland Resort on Katella Avenue. The basketball arena fronting Katella Avenue opened in July 1967, while the convention hall behind it opened to business shortly afterward. Since then, the convention hall has undergone three major expansions and is currently a state-of-the-art facility encompassing over 800,000 square feet of floor space.

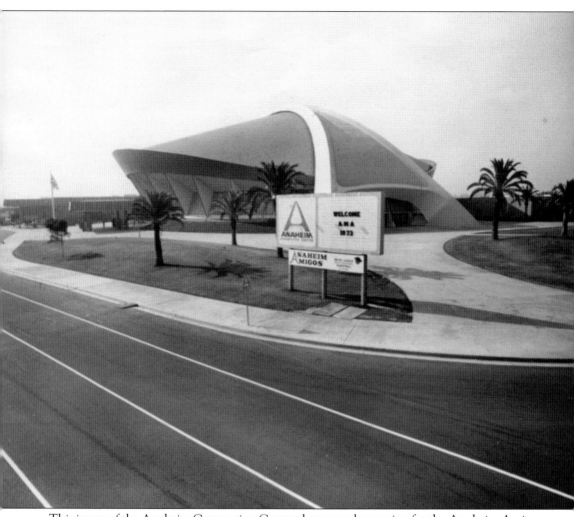

This image of the Anaheim Convention Center shows a welcome sign for the Anaheim Amigos, who were charter members of the American Basketball Association, playing during the league's inaugural 1967–1968 season at this building.

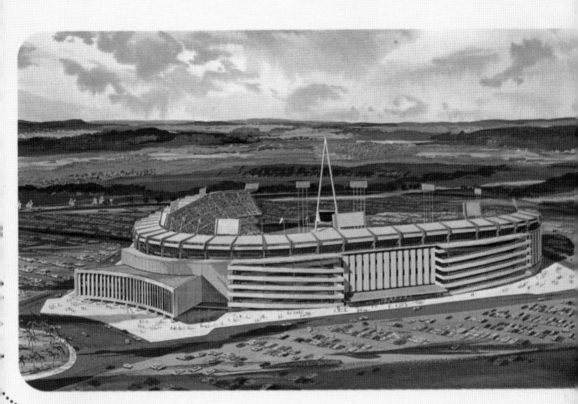

Anaheim Stadium

Angel Stadium (or "the Big A") has been the home of the Angels since their move from Los Angeles. In 1964, ground was broken for Anaheim Stadium, and in 1966, the then-California Angels moved into their new home, after having spent four seasons renting Dodger Stadium (referred to during Angels games as Chávez Ravine Stadium). This promo image for the stadium's opening shows how open and undeveloped the surrounding area was back then, still rich with citrus farms and other agriculture.

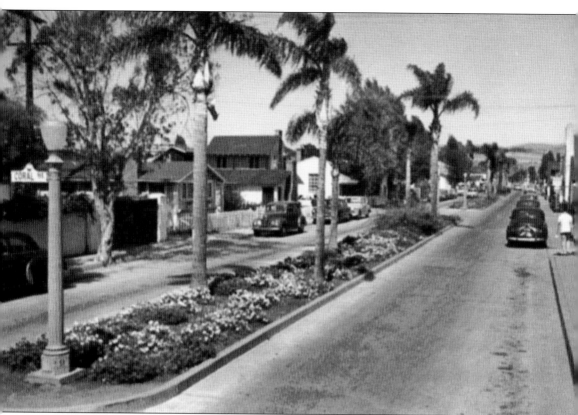

This postcard view shows Balboa Island in 1957. Balboa Island is a charming and popular area of Newport Beach, California, comprised of three modified or artificial islands in Newport Harbor: Balboa Island, the largest; the smaller Little Balboa Island to the east of Balboa Island, joined by a two-lane bridge; and the smallest, Collins Island, to the northwest of Balboa Island, joined by a one-lane bridge. The Balboa Island community connects to the mainland by a short, two-lane bridge on the northeast of Balboa Island and a privately operated fleet of three three-car ferryboats (the famed Balboa Island Ferry) that provide access across the harbor to the Balboa Peninsula, which lies to the south.

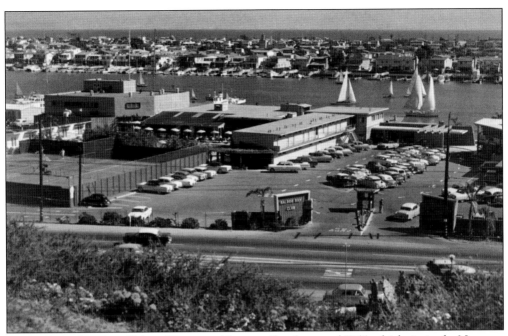

This is the Balboa Bay Club and Resort in Newport Beach around 1956, which sits in the Newport Harbor on 15 waterfront acres. The resort was founded in 1948 and is still going strong.

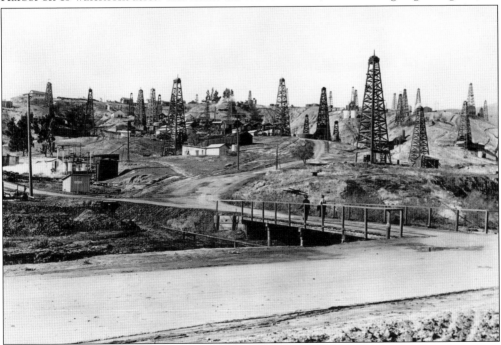

Brea began as a center for crude oil production (as seen in this 1920s photograph) and was later propelled by citrus production. Today the large Brea mall and the recently redeveloped Brea downtown area make this city an important retail center. Brea is also known for its extensive public art program, started in 1975, with over 140 collected works of art placed throughout this attractive city.

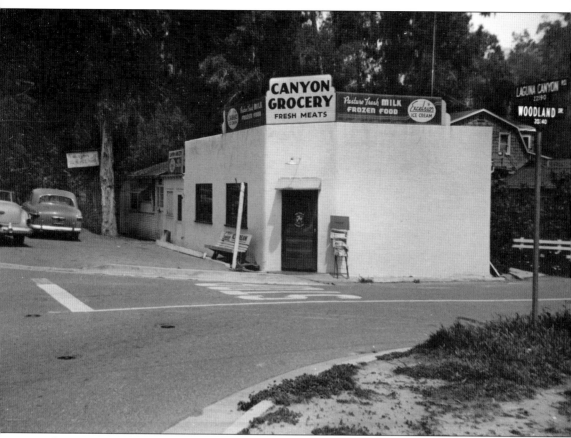

Canyon Grocery once sat at the corner of Laguna Canyon Road and Woodland Drive. This image dates back to the early 1950s.

Cook's Corner in Trabuco Canyon is named for Andrew Jackson Cook, a merchant who acquired 190 acres of land in the South Orange County area. The building was constructed not long after in 1884. In 1926, Cook's son, Earl Jack "E. J." Cook, converted the structure into a restaurant meant to supply food to miners and local ranchers. Seven years later, after the end of Prohibition, Cook's was converted into a bar. A Santa Ana motorcycle accessories owner purchased the building in 1970 and publicized it further, making it one of the more famous hangouts for motorcyclists.

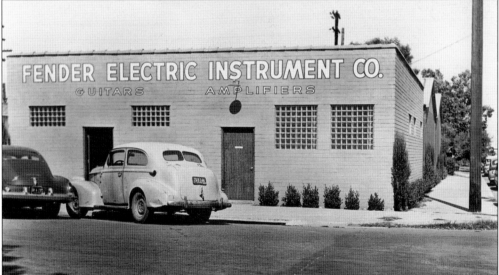

This is where a rock-and-roll legend changed the sound of music: Fullerton's own Leo Fender. As the Rock and Roll Hall of Fame observed, "Rock and roll as we know it could not exist without Leo Fender, inventor of the first solid-body electric guitar to be mass produced: the Fender Broadcaster." While many are familiar with the former site of the Fender Guitar factory near the Fullerton train station (today a parking lot marked by a plaque and mural), the music actually started here on South Spadra Boulevard.

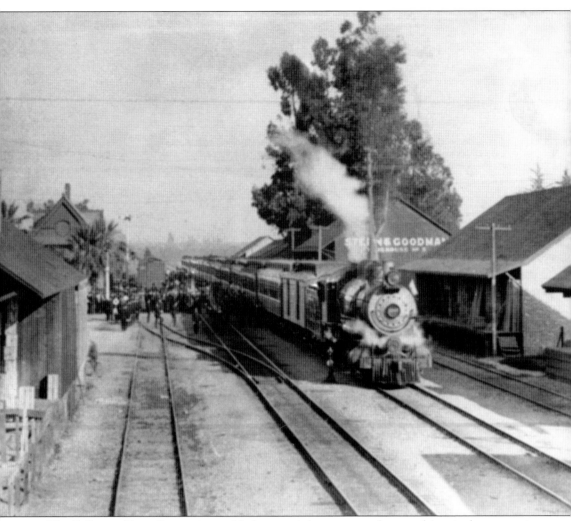

The Fullerton Train Station is notable because it has not one, but two historic depots on site: one was built in 1923 by the Union Pacific Railroad the other erected in 1930 by the Atchison, Topeka, and Santa Fe Railway. Both depots are now on the National Register of Historic Places. The Santa Fe depot is used as an Amtrak ticket office, passenger waiting area, and café, while an Old Spaghetti Factory restaurant occupies the Union Pacific building. This image is from the early 1930s.

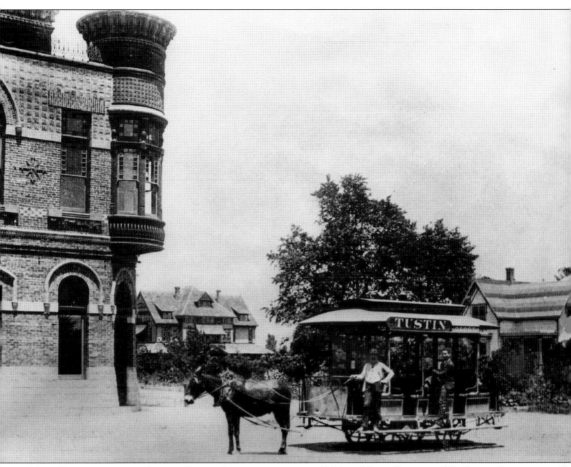

This charming image shows a horse-drawn streetcar in 1890 at Main Street and D Street (now El Camino Real) in Tustin. The First National Bank is at left.

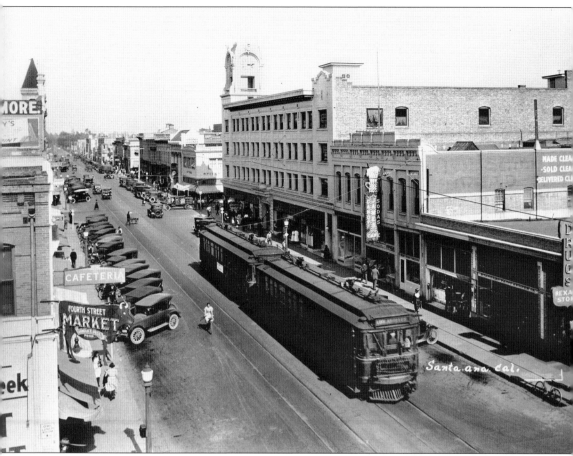

This is Fourth Street in Santa Ana, looking east, c. 1920s. Signs and storefronts are visible, including the James Café and the Fourth Street Market.

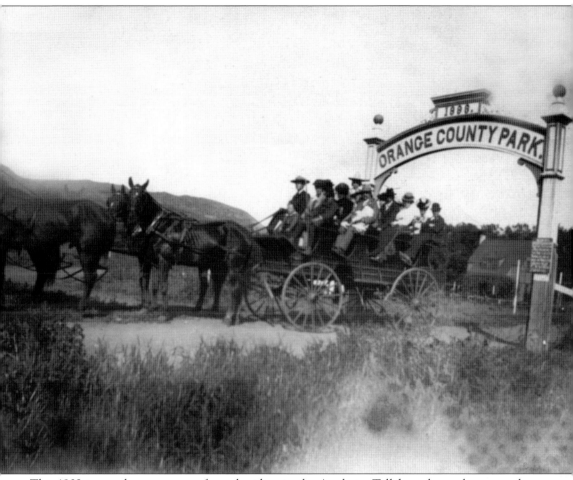

This 1902 image shows a group of people riding in the Anaheim Tallyho, a horse-drawn coach available for hire from the Palace Stables, located at 201 South Los Angeles Street (now Anaheim Boulevard) at Chestnut Street. This view shows the coach, pulled by two teams of horses, standing under the gate reading "ORANGE COUNTY PARK / 1898" found at the entrance to the park.

This is a photograph of the Golden Bear nightclub in Huntington Beach, just a year or two before it was razed in the mid-1980s.

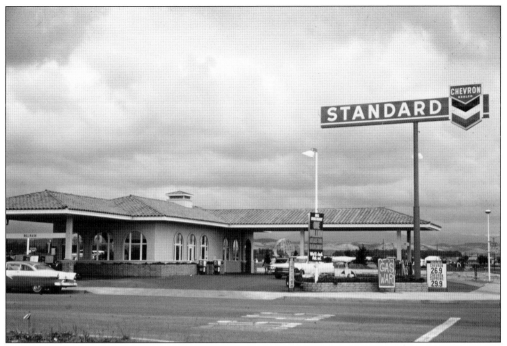

This 1966 image shows the gas station at Leisure World, a gated retirement community in Seal Beach. Construction began in 1960, and the earliest residents moved in on June 6, 1962. This was the first major planned retirement community of its type in the United States.

The Richard Nixon Presidential Library and Museum in Yorba Linda, California, is one of 12 libraries administered by the National Archives and Records Administration. This is Nixon's birth site, originally dedicated in 1990, and the house adjacent to the museum is open for tours. Former president Nixon and his wife, Pat, were laid to rest on the grounds.

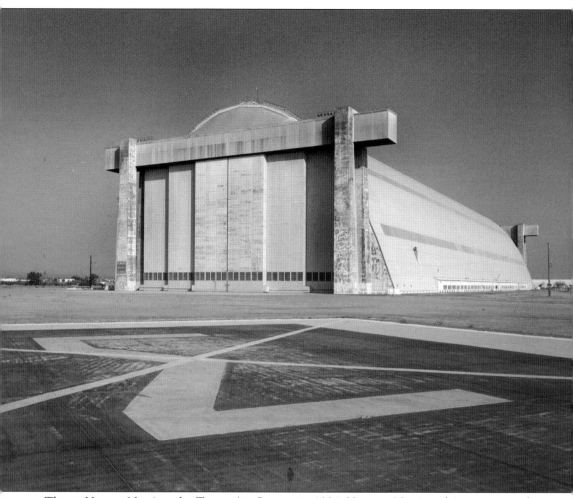

This is Hangar No. 1 at the Tustin Air Station in 1984. Hangars No. 1 and 2 are among the largest wooden structures ever built and are listed on the National Register of Historic Places and the ASCE List of Historic Civil Engineering Landmarks.

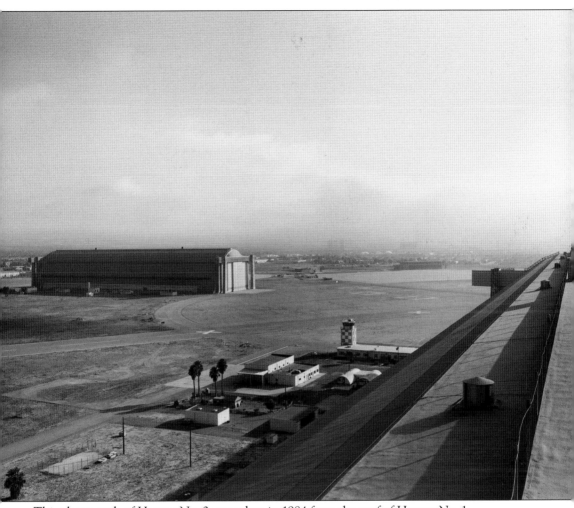

This photograph of Hanger No. 2 was taken in 1984 from the roof of Hanger No. 1.

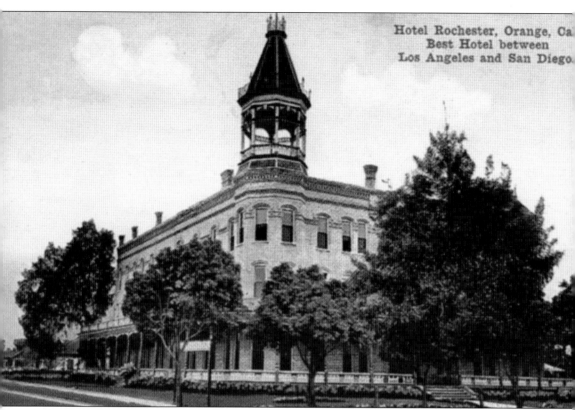

Hotel Rochester, Orange, Cal
Best Hotel between
Los Angeles and San Diego.

Construction on the Rochester Hotel began in 1887. Located at 310 West Chapman Avenue at the southwest corner of Lemon and Chapman, the building operated as a hotel until it was razed in June 1931. On the site now is the Orange Post Office, which opened in 1935.

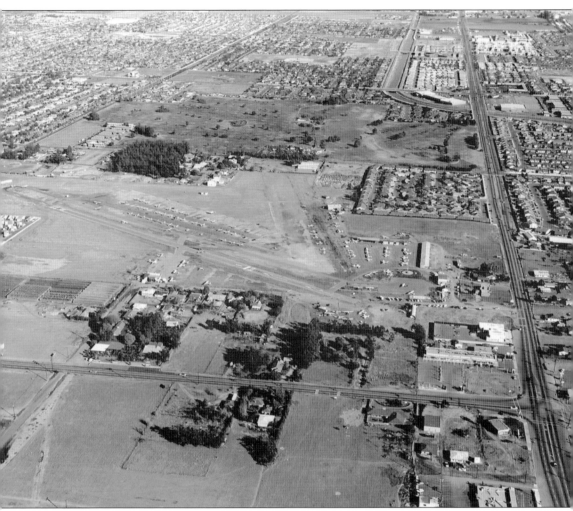

This mid-1970s aerial view of the Meadowlark Airport in Huntington Beach provides a good view of the development that was beginning to take place in the city. Today a shopping center and housing development occupy the site.

Mission San Juan Capistrano was founded on All Saints Day, November 1, 1776, by Spanish Catholics of the Franciscan order. Named for a 15th century theologian and "warrior priest" who resided in the Abruzzo region of Italy, San Juan Capistrano has the distinction of being home to the oldest building in California still in use. This image is from the 1930s.

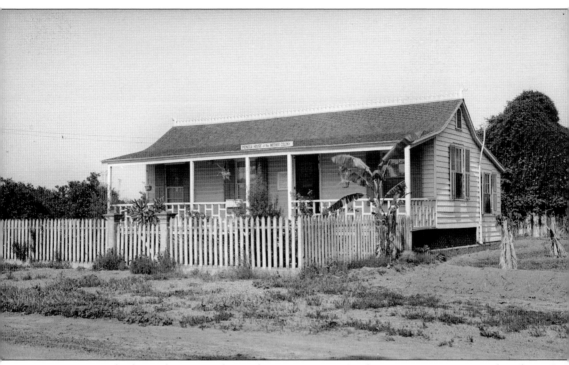

George Hansen built Anaheim's Mother Colony House in 1857 when German immigrants hired the San Francisco resident to plan the layout for the settlement that would become Anaheim. The house was dedicated as a museum on March 14, 1929, making it the oldest museum in Orange County.

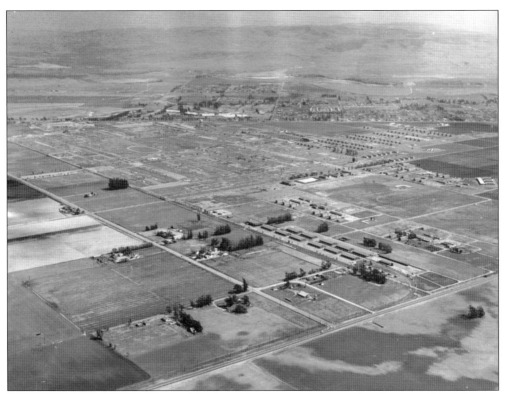

This is an aerial view of the Santa Ana Army Air Base and surrounding farms in 1948. This site is now the home of Orange Coast College in Costa Mesa.

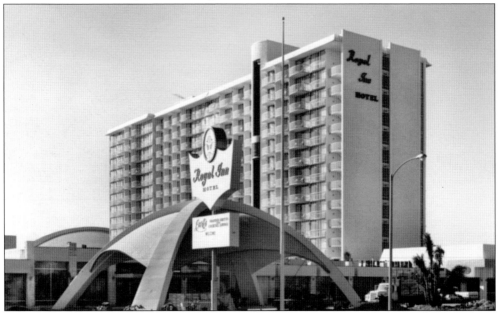

This 1971 image shows the front facade of the Royal Inn of Anaheim complex at 1855 South Harbor Boulevard. On the right is the inn's 13 story, 500-room tower. Also clearly visible is the Googie-inspired white concrete half-dome over the driveway at the front entrance.

Seven

STILL STANDING!

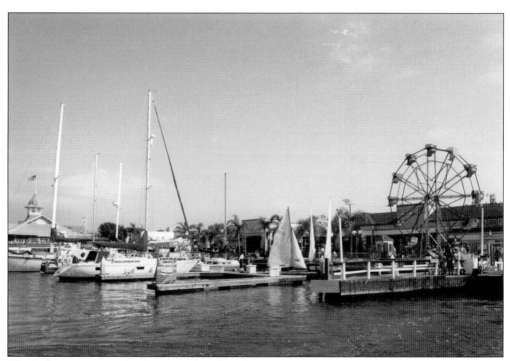

The Balboa Fun Zone, built in 1936 by Al Anderson, was an arcade and amusement park located on the Balboa Peninsula. Bob Speth, a former employee, bought the Ferris wheel in 1956 but sold it back in 1964. When Jordan Wank rebuilt the entire park and reopened it in 1986, the attraction had been closed due to legal problems since 1972. On September 30, 2006, most of the rides—the Drummer Boy, Bumper Cars, and Scary Dark Ride—were closed and removed to make room for the Newport Harbor Nautical Museum. Today only the Ferris wheel and the merry-go-round remain as reminders of the park's past.

Just 100 yards from Disneyland's south entrance is the venerable Alpine Inn, with its faux-snow-covered roof and Swiss Alps design. Built in 1959, it is one of many area structures that was theme inspired by its close proximity to the famous park.

Opened in 1922, Newport's Arches Restaurant became famous for catering to movie stars like Gary Cooper and John Wayne. The structure still stands, made over recently as another restaurant.

An original Disneyland bandstand sits at the legendary Roger's Gardens in Newport Beach. A sign on the piece details its history.

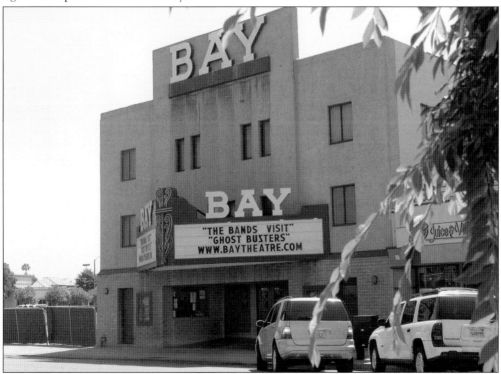

Since 1947, the Bay Theater has stood near the corner of Pacific Coast Highway and Main Street in Seal Beach. Over the years, it has been home to mainstream movies, surfing films, and concert performances. Today they offer independent and foreign films, plus special weekly screenings of classics.

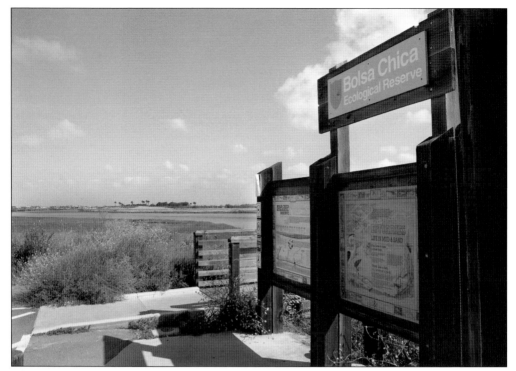

The Bolsa Chica Ecological Reserve in Huntington Beach was designated by the California Department of Fish and Game to protect Orange County's coastal wetland and its resident threatened and endangered species. Bolsa chica means "little pocket" in Spanish, as the area was part of a historic Spanish land grant named Rancho Las Bolsas. Environmentalists have waged long and (for the most part) successful fights over the years to protect this precious piece of Orange County.

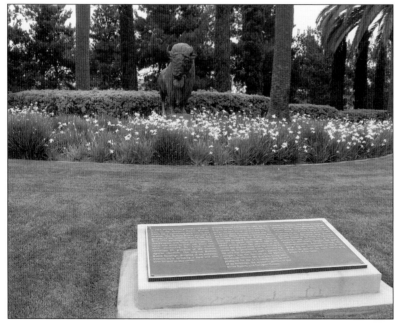

A buffalo statue was placed at the site of the old Buffalo Ranch in Newport to commemorate this much-missed attraction.

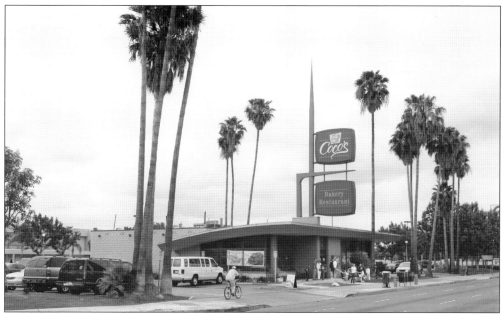

There's a Coco's restaurant in Anaheim that harkens back to another age. Historian Chris Jepsen comments on the building: "Designed by the Googie architects Armet & Davis, this Coco's sits nestled on the corner of Chapman and Harbor Boulevard, minding its own business. Little has changed about the exterior of this building since it opened as the first Bob's Big Boy, designed by the legendary architects in 1957. Those concrete pillars holding up that beautiful sloping roof used to be covered in flagcrete, but considering the preservation apparent in the rest of the building, its removal can be forgiven. Those jutting pylons still shoot out of the sign, announcing yet another greasy spoon off the road."

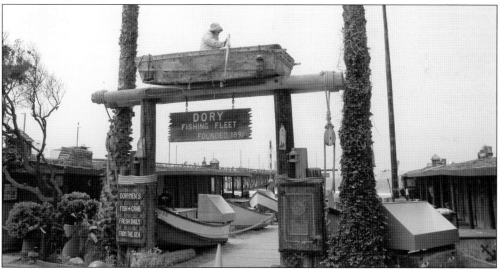

The famed Dory Fishing Fleet in Newport Beach is a beachside fishing cooperative that was founded in 1891 at the base of what was then McFadden Wharf (now known as the Newport Pier). Considered the last beachside cooperative of its kind in the United States, each day fresh catches are hauled onto shore around 9:00 a.m. and gourmet restaurants, shops, and private citizens arrive to purchase the bounty.

Known as Orange's oldest burger stand, Dairy Treet opened in 1949 at 292 North Glassell Street on the former site of a local family's victory garden. For 50 years, proprietors have been serving up burgers and fries and mixing shakes from fruit, cookies, candy, and real ice cream.

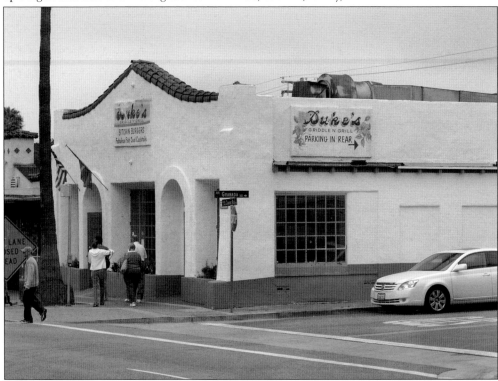

Duke's, located at 204 South El Camino Real in San Clemente, was originally called Victor McLaglen's Rendezvous. It was well known as a popular rest stop for Hollywood actors like Bette Davis and Clark Gable during the Del Mar racing season. Thankfully, it is still in business.

The Fox Theater on Harbor Boulevard in Fullerton was designed in 1925 by architect Raymond M. Kennedy of the firm Meyer and Holler, who later designed Grauman's Chinese Theatre in Hollywood. The original name of the theater was the Alician Court Theater, in honor of Chapman's wife, Alice. An official landmark of the City of Fullerton since 1990, the Fox Theater was added to the National Register of Historic Places in October 2006. The Fullerton Historic Theatre Foundation is currently in the process of fund-raising and restoring the theater.

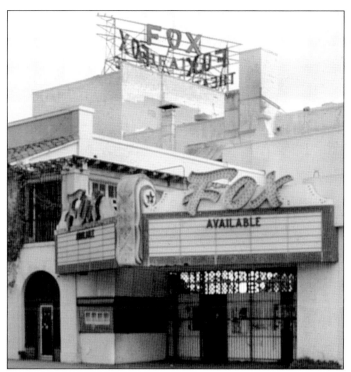

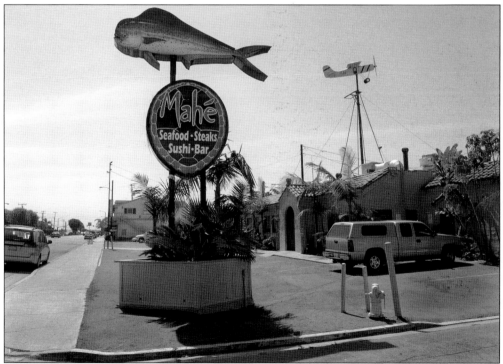

Today this building in Seal Beach is a restaurant called Mahe, but the plane model on top reminds observers that it was once the classic Glider Inn restaurant. Back in the 1920s, the restaurant was actually part of an airport and was visited by both Amelia Earhart and Charles Lindbergh.

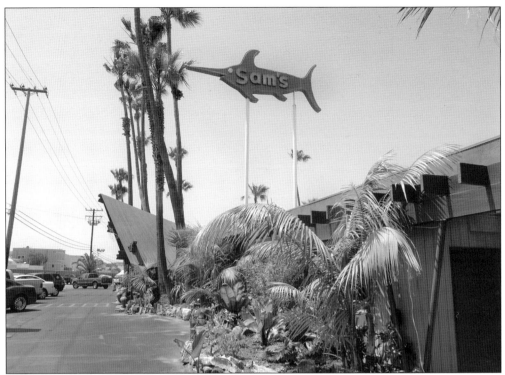

Sam's Seafood, the last authentic 1960s tiki-themed establishment in Orange County, was recently rescued from the bulldozer. Renamed Kona, the restaurant continues with the islands-inspired theme that Sam's maintained for decades on Pacific Coast Highway in Seal Beach.

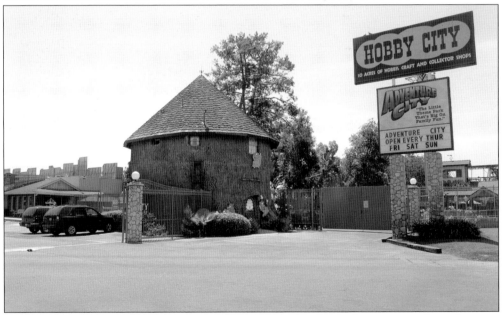

Hobby City on the Stanton/Anaheim border seems to shrink a little every month, and rumors keep flying about impending closure. Still, the attraction continues to run, along with the quaint Adventure City amusement park.

La Palma Park on Anaheim Boulevard in Anaheim is a 21-acre park that is home to the historic Glover Football Stadium, Dee Fee Baseball Field, and Martin Recreation Center. Joe DiMaggio played baseball here when stationed in the army in nearby Santa Ana.

The Lido Theater in Newport opened in 1938, and the first film shown was *Jezebel*, starring Bette Davis. Davis lived nearby in Corona Del Mar and frequented the theater. Upon stopping onsite one time before it officially opened, she told the owner that he'd "Better open with my picture." And they did. The entire theater has been restored, down to the tile work done in the 1930s by an Italian family. (The tile setting, called Catalina Tile, is extremely rare.) The original family restored the tile.

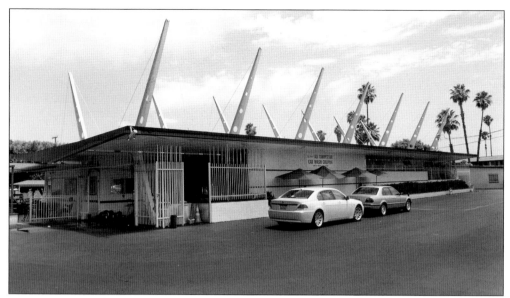

The Beach-Lin Car Wash on Beach Boulevard in Anaheim, with its stylish exposed steel beams interlocked by wire, reflects the space-age look made popular in the late 1950s and early 1960s. Opened around 1960, the Beach-Lin remains a valuable Googie artifact in Orange County.

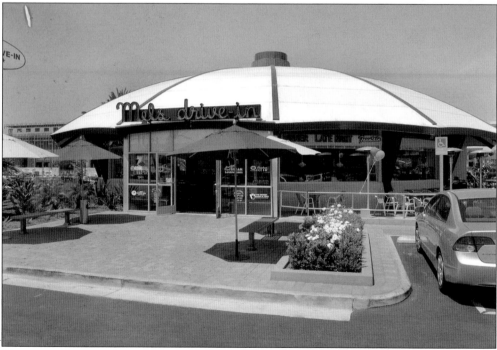

The iconic, Googie-style restaurant known as the Parasol was built in 1967 in Seal Beach. It operated as the Parasol Restaurant until an overhaul of the surrounding shopping center threatened it with demolition in 2004. Fortunately, a group of Parasol enthusiasts banded together and gathered over 10,000 signatures on a petition to save it. Lease negotiations with the former operator fell through, however, and the restaurant closed in March 2006. It reopened as Mel's in November 2007 with the parasol shape still intact.

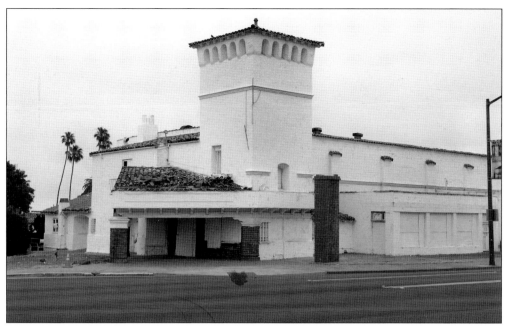

Built in 1937, the Miramar Theater at 1598 South El Camino Real in San Clemente was once the most elaborate theater development on the entire south coast. Today local preservationists are working hard to save the building's original elements, including its unique Spanish Colonial tower.

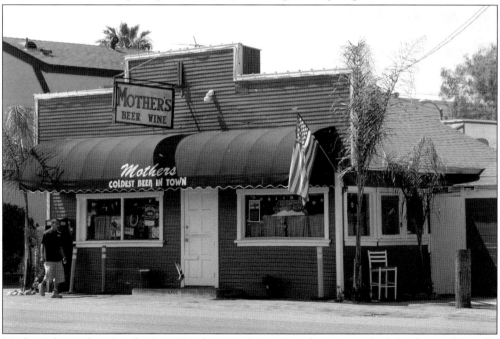

Mother's, located on Pacific Coast Highway in Sunset Beach, is a popular biker bar and friendly neighborhood hangout. Rumor has it that this historic building used to be the ticket station for the Pacific Electric train line that once came from Los Angeles to Orange County beaches. A window in the back looks like it could at one time have been a ticket window, but the jury is still out on this one. Nevertheless, this is a wonderfully historic building to have still standing.

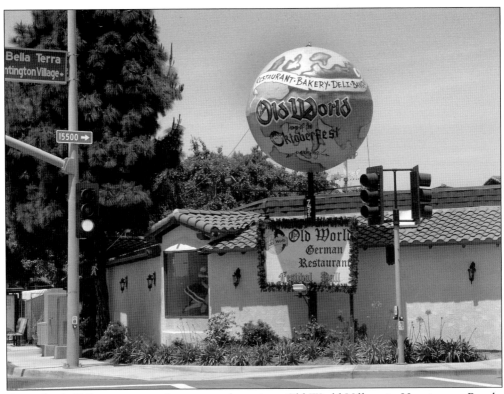

A touch of old Europe awaits shoppers at the unique Old World Village in Huntington Beach, built in the image of a Bavarian village. Old World was the creation of Joe Bischof, and when the village opened its doors in September 1978, it was an instant hit. From then on, Huntington Beach had an unparalleled tourist attraction.

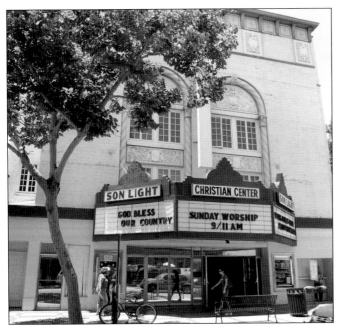

The Son Light Christian Center now occupies what was once the beautiful Orange Theater in the city of Orange. The theater opened on May 22, 1929, with the movie *Molly and Me*, starring Belle Bennett and Joe E. Brown, plus a vaudeville show and Wurlitzer organ music. It had a seating capacity of 1,300 and was operated by Fox West Coast-Langley Theaters. The Orange Theater closed to films in the early 1970s and briefly went over to being a live theater, but closed in 1975. The building's current church use commenced in 1978.

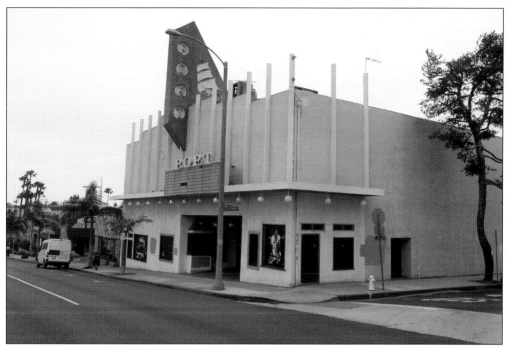

Opened in the early 1950s, the 900-seat Port Theater in Newport was popular for years, first as a mainstream cinema and later as an art house. Though, at the time of this writing, the theater is not open to the public, there are preservationists currently at work to save this classic building and have it restored to function once again as a movie theater.

In an age when many old structures are not so lucky, the White House Restaurant and Nightclub in Laguna Beach has found a way to exist, even thrive. According to the restaurant's Web site, this establishment "is almost certainly the oldest restaurant in Orange County. First established in 1918, it later became very popular with stars of stage and screen from Hollywood when they would come to dine and hear the latest popular music by the sea in Southern California. Totally renovated and remodeled, it is now in the forefront of innovative casual California cuisine. The dining room displays an ever-changing exhibition of artwork by local Laguna Beach artists."

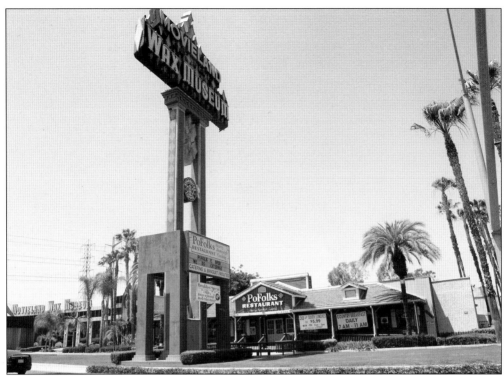

The Movieland Wax Museum in Buena Park closed its doors on October 31, 2005, after years of dwindling attendance, but the building remains, albeit empty. The celebrity handprints in cement out front are still there.

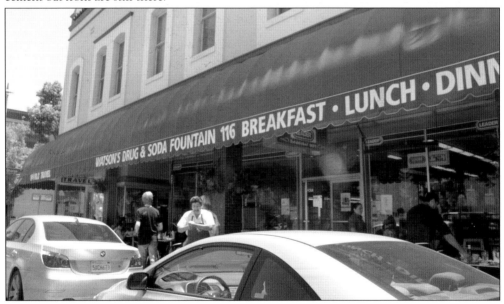

The fabled Watson's Drug Store has been in business here in Orange since 1899. Complete with an old-fashioned soda fountain and lunch counter, visiting the drugstore is a wonderful experience. Watson's has been featured in many movies, television shows, and commercials, including Tom Hanks's *That Thing You Do*.

The Best Western Stovall's Inn near Disneyland boasts a few space-age Googie touches, including the poolside, globe-shaped cabana. A kitschy trace of the past, the inn has managed to survive an age when many other structures in the area are being destroyed on a regular basis.

The Shack on Pacific Coast Highway in Newport, near Crystal Cove, has been operating since 1946. Though they serve good burgers, shakes, and fries, they are famous their date shakes, made thick and fresh daily. In 2006, The Shack was taken over by the restaurant chain Ruby's, who seems to have maintained much of the old time charm of the place.

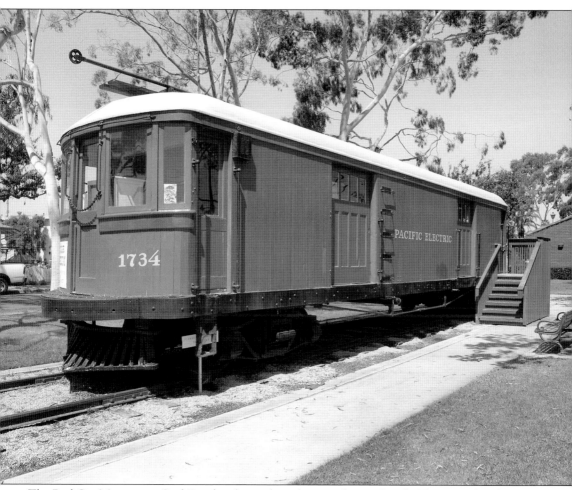

The Red Car Museum in Seal Beach is located inside an authentic Pacific Electric right-of-way. Car No. 1734 is a rare Pacific Electric tower car built in 1925. Many years ago, it was a roving machine shop sent out to troubleshoot problems along the 40-mile Pacific Electric L.A.–Newport Line. Though small, this is a wonderful museum that truly makes one think about how different life could be in Orange County had the transit system been maintained.

ACROSS AMERICA, PEOPLE ARE DISCOVERING SOMETHING WONDERFUL. *THEIR HERITAGE.*

Arcadia Publishing is the leading local history publisher in the United States. With more than 4,000 titles in print and hundreds of new titles released every year, Arcadia has extensive specialized experience chronicling the history of communities and celebrating America's hidden stories, bringing to life the people, places, and events from the past. To discover the history of other communities across the nation, please visit:

www.arcadiapublishing.com

Customized search tools allow you to find regional history books about the town where you grew up, the cities where your friends and family live, the town where your parents met, or even that retirement spot you've been dreaming about.